# AGING GRACEFULLY

# AGING GRACEFULLY

## Portraits of People Over 100

KARSTEN THORMAEHLEN

**CHRONICLE BOOKS**
SAN FRANCISCO

Library of Congress Cataloging-in-Publication Data:

Names: Thormaehlen, Karsten, photographer.
Title: Aging gracefully : portraits of people over 100 / Karsten Thormaehlen.
Description: San Francisco : Chronicle Books, [2017]
Identifiers: LCCN 2016010962 | ISBN 9781452145334
Subjects: LCSH: Centenarians—Portraits. | Centenarians—Interviews. |
  Portrait photography. | Longevity.
Classification: LCC TR681.A35 T46 2017 | DDC 779/.2—dc23
LC record available at https://lccn.loc.gov/2016010962

Manufactured in China

10 9 8 7 6 5 4 3 2 1

Chronicle Books LLC
680 Second Street
San Francisco, California 94107
www.chroniclebooks.com

"LIFE IS LIKE RIDING
A BICYCLE. TO KEEP
YOUR BALANCE, YOU
MUST KEEP MOVING."
—ALBERT EINSTEIN

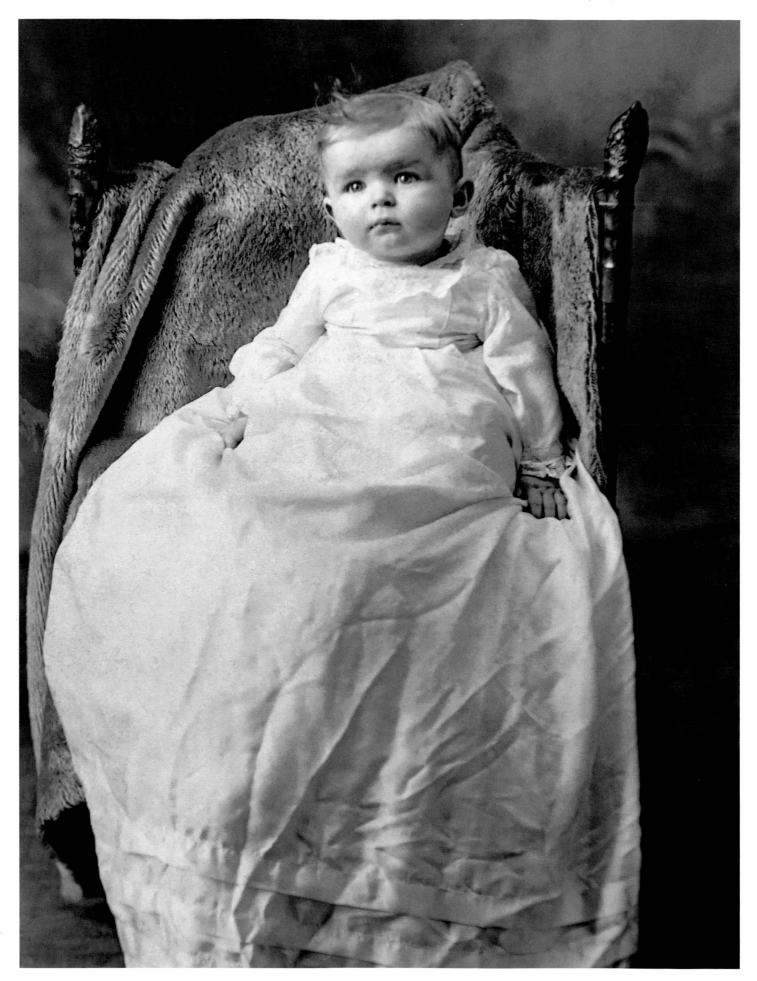

*Edward Palkot as a baby.*

# The Good, Old Days

Edward J. Palkot

---

Life is full of surprises. A while back a book came in the mail: *Happy at Hundred* by Karsten Thormaehlen. I learned that one of my sons had brought my own status as an active elder statesman to Karsten's attention. I'm glad that he did because I find this type of book valuable for the cause of seniors worldwide.

Oh, the "good old days"—what was so wonderful about them? Bathing once a week in a washtub of water shared by the whole family. Watching my mother scrub clothes on a rickety washboard. Waiting for the iceman to bring in a big cake of ice for the ice box. And on and on. Would you call that wonderful? Not I.

Somehow we managed in Pittsburgh, Pennsylvania, known as the "steel city," manned by men with brawn, where in the spring and fall streetlights had to be turned on at noon because of the heavy smog blocking out the sun. When people ask me how I reached the age of 102, I simply tell them I built up so much resistance breathing that air, and drinking from the rivers polluted by chemicals discharged by the mills, that here I am.

I still remember World War I, seeing a truck loaded with soldiers headed for the front. And I have a clear memory of November 11, 1918, when my father placed a sign in his tailor shop: "Closed for the Armistice."

When I entered the first grade of the Conroy School in 1919 (we didn't have kindergarten), I was bewildered and remained so until the third grade. It was then that my teacher had me take the drama role of George Washington going to Betsy Ross's house to sew the first American flag with its 13 stars. Sitting on the stage were five Civil War Union soldiers in uniform. My interest in the theater was born.

Sometime after this, my father sold his business and we moved to his new venture, the McKees Rocks Hotel. It was then that I began my driving lessons at age 15 in a 1921 Hudson with no power brakes, no power steering, no heater. To shift gears I had to use a clutch. I managed to get my driver's license at age 16 and have been driving ever since.

My interest in the theater continued, and in the seventh grade I had a role in an operetta. All these years later, I still sing the ditty

about St. Patrick and his "shnakes" on St. Patrick's Day. It was natural that I enrolled in the School of Drama of the Carnegie Institute of Technology (now Carnegie Mellon University), graduating in the deep depression of 1935. Jobs were hard to find, so I went into teaching speech and directing amateur plays on Long Island, New York.

While I was studying for my master's degree at Columbia's Teachers College I was out at a local tavern in Great Neck when I met a young man of Lithuanian heritage (I, too, have Lithuanian roots) who suggested that I meet his sister, Anne. After Anne and I met, the sparks began for me—though not necessarily for her! Nonetheless I pursued her for some time before I proposed marriage with a ring. We were engaged on New Year's Eve 1939 but we kept it secret for a while. Eventually we got married on April 5, 1942.

Anne would eventually bless me with two sons and two daughters. She was a wonderful mother who kept me from being too strict with the children, but accepted the discipline I gave regarding the importance of an education, limiting access to the newly acquired TV set, and so on. Our children have gone on to have successful professional careers and wonderful families of their own.

My poor vision kept me out of active service in World War II, but during the war years I was very active as a personnel man at the huge Sperry Gyroscope plant on Long Island. Afterward I continued my personnel career

in Connecticut, and finally retired in 1978 as Vice President of Human Resources for Marine Midland Bank in Manhattan. In my retirement I remained active in a number of clubs, including the Garden City Retired Men's Club, where I served as president (and where we gather for a few mean games of cribbage every week), a travel group with whom I saw a bit more of the world and with whom I still socialize, and the Knights of Columbus (Senior), who have made me president now.

Golfing—a lifelong love—takes up some of my time. Our foursome at the Salisbury Senior Golf Club at Long Island's Eisenhower Park received some publicity for being the oldest group there. We consisted of a man with Irish heritage (age 89), a man with German heritage (age 92), a man with Italian heritage (age 96), and me, with Lithuanian heritage (age 102). The local newspaper, *Newsday*, ran a story and picture of our foursome, which hangs on the club wall. This congenial foursome, drawn from four different nationalities, demonstrates what makes America a great country.

My children blessed me with six grandchildren and nine great-grandchildren. After my dear wife, Anne, died of ALS (Lou Gehrig's disease), I had the good fortune five years later to develop a warm friendship with a woman named Alice, whose late husband had been Anne's first cousin. Alice has three daughters, and grandchildren and great-grandchildren of her own. Extended family gatherings for holidays and personal milestones are regular, including fishing

trips at my daughter Barbara's seaside home.

I'm still living on my own in a lovely home, tending my garden, shopping and running errands, stopping in at local restaurants for great food, keeping up with my reading, doing crossword puzzles, and chatting with my neighbors. I keep my feet active doing the polka and my appetite sated by eating pierogies at a Polish restaurant. And when people ask me how I do it, I reply, "The first hundred years are the hardest—after that you just roll along."

As I look back, I dwell on all the changes the world has seen during my lifetime. From a handmade crystal radio in 1921 to today's digital technology (I use e-mail, Facebook, and Twitter). Early automobiles requiring handheld crankshafts. Iceboxes replaced by modern (ice-making!) refrigerators. Gas lamps giving way to energy-saving electric bulbs. Aviation going from the rickety planes I once flew in to supersonic jets. On and on and on.

What a wonderful world. I would have it no other way.

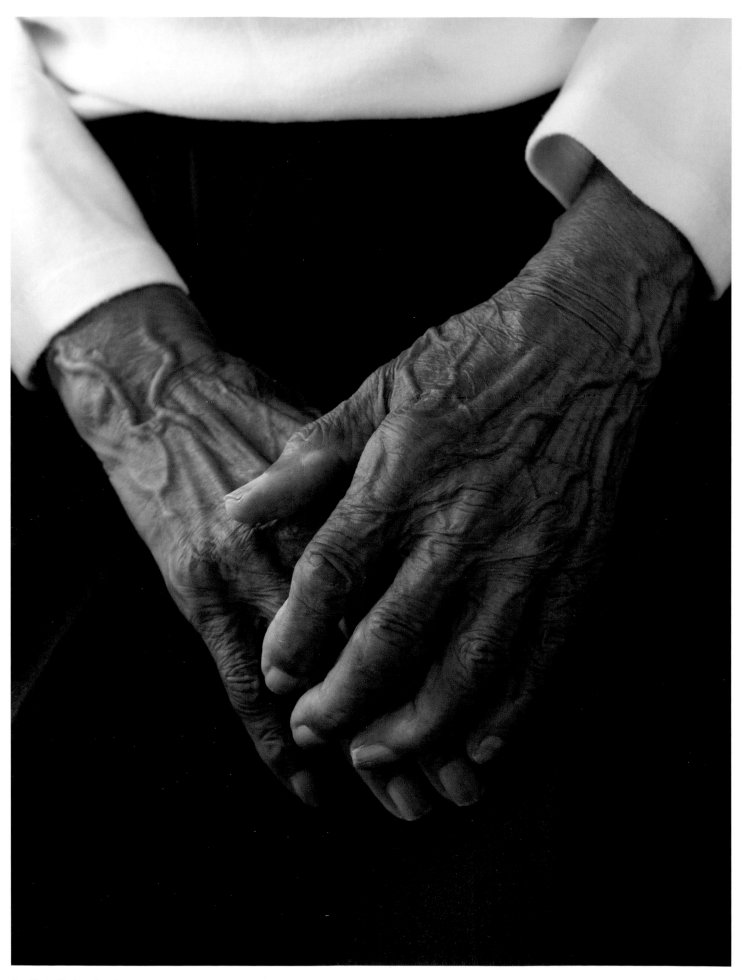

*Dr. Olivia Hooker's hands*

# Timeless Beauty

Karsten Thormaehlen

---

You might assume that as a professional photographer I'd prefer to put luxury goods, celebrities, and models in front of the lens. But my ultimate passion is photographing old people. Very old people. Maybe it is because, in my previous work as an advertising art director, I had sufficient opportunity to experience the life of a photographer as one would typically imagine it. I traveled the world, visiting the most sought-after and exclusive places on earth, with the most attractive people, presenting premium fashion and cosmetics brands in their best light. In many ways it was a wonderful, exciting time. But it also made me yearn for new challenges and to seek a subject beyond these staged dream-worlds, something that had more to do with myself. With humanity. With our existence. With the future.

I set off in search of another kind of beauty, perhaps the truest kind—a beauty that knows no expiration date. A timeless beauty that only grows over the years. A beauty that springs from life itself, from experience, wisdom, curiosity, pleasure, passion, and optimism, but also speaks of the hardships of everyday life, of defeats and victories. This kind of beauty does not need hairdressers, stylists, or makeup artists. To attain this

beauty you need a few decades—or, better yet, an entire century.

During my childhood I spent a lot of time with my father's parents and my mother's mother. We lived on the same street in a small town in southwest Germany. I loved the feeling of security my grandparents gave me. I loved my grandmother's roasted potatoes, and the swing and the merry-go-round my grandfather set up in his garden just for me. I loved that he was able to create an entire children's world, just like that—all he needed was a toolbox. I loved our conversations, their easy-going nature and generosity, and the kind way they looked at me—as if they already knew the answers to so many things before I could even come up with the questions. I admired my grandparents for their authority, patience, cleverness, and nobleness of heart, for their trust in me and also their trust in life itself, despite all the horrors their generation had lived through. They taught me something essential: Life is what gives life its meaning.

My initial photographic work with old people began in the mid 1980s, when I was in my early 20s, during my 18 months of alternative national service in a retirement home where I documented daily life in the residence.

Now I photograph people who have lived for a century. These people have seen, experienced, and lived through more than most of humanity. I can hardly think of anything more thrilling or exciting than to search for these people, sit before them, see their faces, and hear their stories.

The shoots were always an adventure. For my July 2015 meeting with Susannah Mushatt Jones in New York, I accidentally waited for 90 minutes in the wrong apartment building before realizing my mistake. At that time, she was one of only a few people born in the 19th century still living, and I was eager to take her photograph. But by the time I arrived, Susannah was taking a nap. So I photographed her while she slept in natural daylight. For all of the images in this book, I believe that light

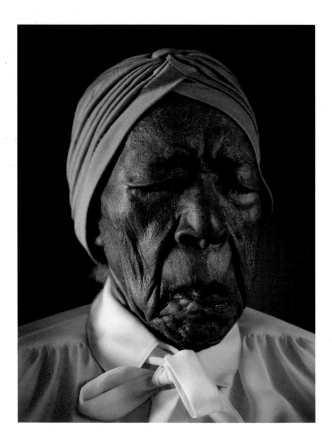

*Susannah Mushatt Jones*

gives the portraits their magic and power—showing the faces as they are and letting them tell their own story.

As I traveled the world pursuing the subject of old age, I met magnificent people who touched me with the stories about their lives. Sometimes they themselves were surprised at how old they had become and were able to laugh about it. One of my subjects said, "If you had offered to photograph me 70 or 80 years ago, it would have made your job much easier." I looked through many photo albums during these visits, including one belonging to 102-year-old Edward J. Palkot, whom I visited in Garden City, New York. During our meeting he showed me a well-kept photo of himself as a 2-year-old taken in 1915 in his hometown of Pittsburgh.

When we look into the faces of the elderly, we are ultimately looking into our own future. We learn so much in doing so. We learn that aging is a law of nature, part of a brilliant whole. It follows a universal principal: It is constant, irreversible change. It begins the day we are born and is not over until we die. But this is necessary, because without decay, life would not be so infinitely precious. Aging has its own laws, but it is only our attitude and our judgments that make it into something positive or something frightening. We are the ones who determine how we age, and if we are smart, we will regard the aging process with the same remarkable serenity, curiosity, and humor that I discovered in the people I photographed for the following pages. I hope their perspectives are as endearing, fascinating, and exhilarating to you as they have been to me.

# 52

## PORTRAITS

—— of ——

## PEOPLE OVER

# 100

# Zoila Donatila Aliaga Melendez vda de Roman

LIMA, PERU

---

"Where are all the old people?" Zoila likes to ask her daughter when she and her acquaintances gather to pray. She does it twice a day: in the morning for an hour, and in the afternoon, when she prays the rosary. Her prayers aren't necessary for her frequent card games, though: She cheats at cards often and with passion— and, as she so proudly says, is quite good at it. Above all, her prayers are her way of saying thanks. She believes that her faith is what has allowed her to grow so old. Zoila married at 19, had 8 children, and provided for herself until she was 80. Her progeny today include 21 grandchildren, 23 great-grandchildren, and 3 great-great-grandchildren. She likes to read and knit, and was never once seriously ill in her entire life.

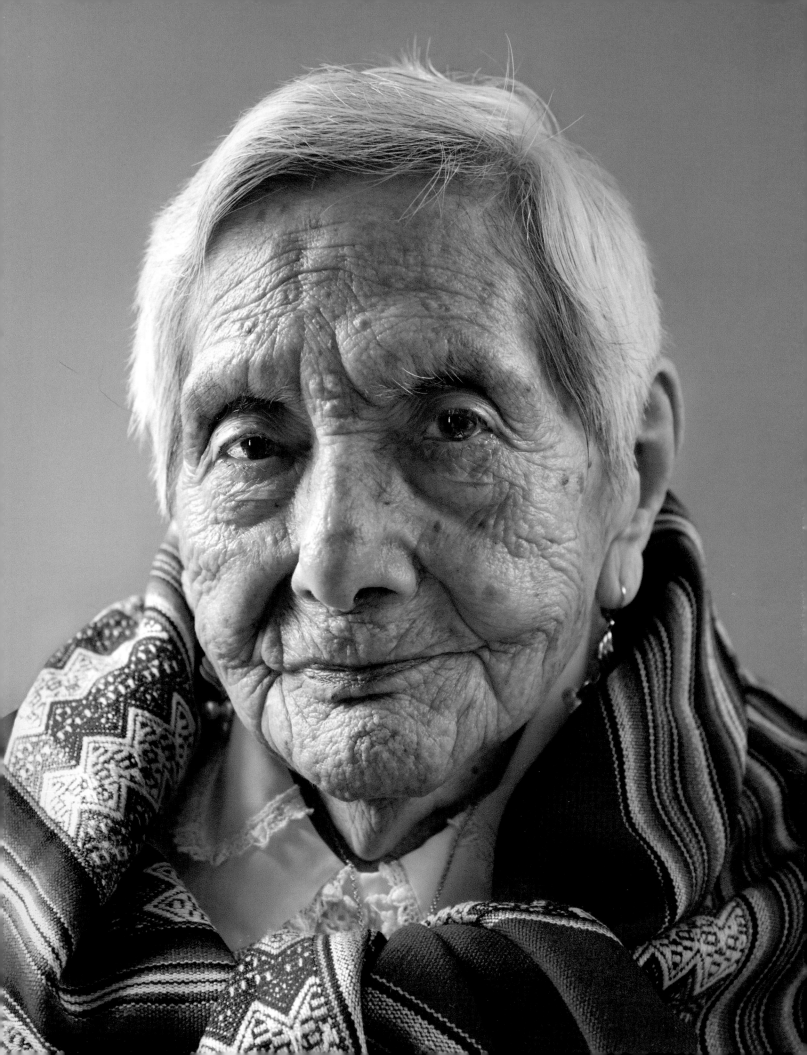

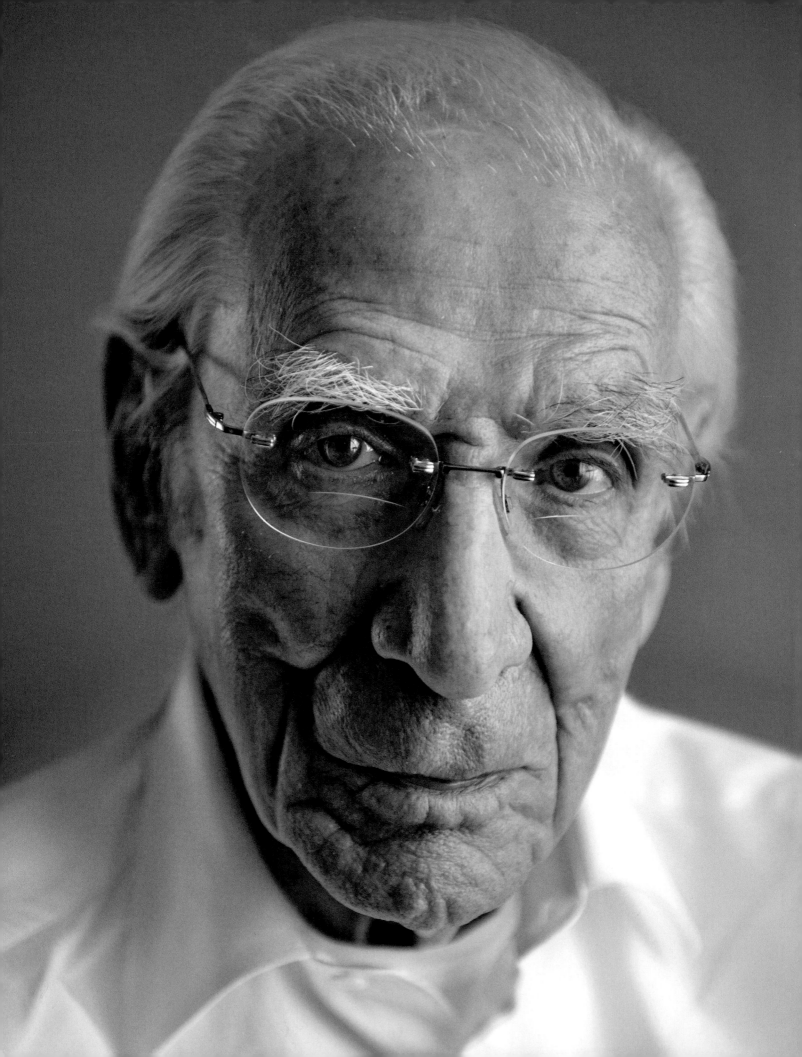

# Lukas Ammann

MUNICH, BAVARIA, GERMANY

---

Swiss-born Lukas Ammann is presumed to be the oldest actor in the world and one of the last true grand seigneurs on this planet. Those who come calling at his apartment, in the Maxvorstadt borough of Munich, are greeted at the door by the epitome of *savoir vivre* (style and nobility), dressed in an elegant three-piece suit with a perfectly matching tie. The son of a singer and a painter, he speaks about his eventful life as a television and film star in the 1960s and '70s, and as a voiceover artist for actors like Peter Sellers. Those were the days. "There are hardly any good television series now," says Ammann. "I feel so uninspired!"

BORN SEPTEMBER 10, 1914,
IN ASAHIKAWA, HOKKAIDO, JAPAN

# Kiyo Aragai

SAPPORO, HOKKAIDO, JAPAN

---

Kiyo says she had a free, idyllic childhood and a wonderful marriage "full of happiness and without any arguments." She has her husband to thank for the fact that she has become such a good cook, "thanks to his wonderful sense of taste and his weakness for good food." The couple traveled a lot, including to places abroad like Hawaii. She says she does not really have anything to complain about, nor does she have any regrets. She is at peace with herself.

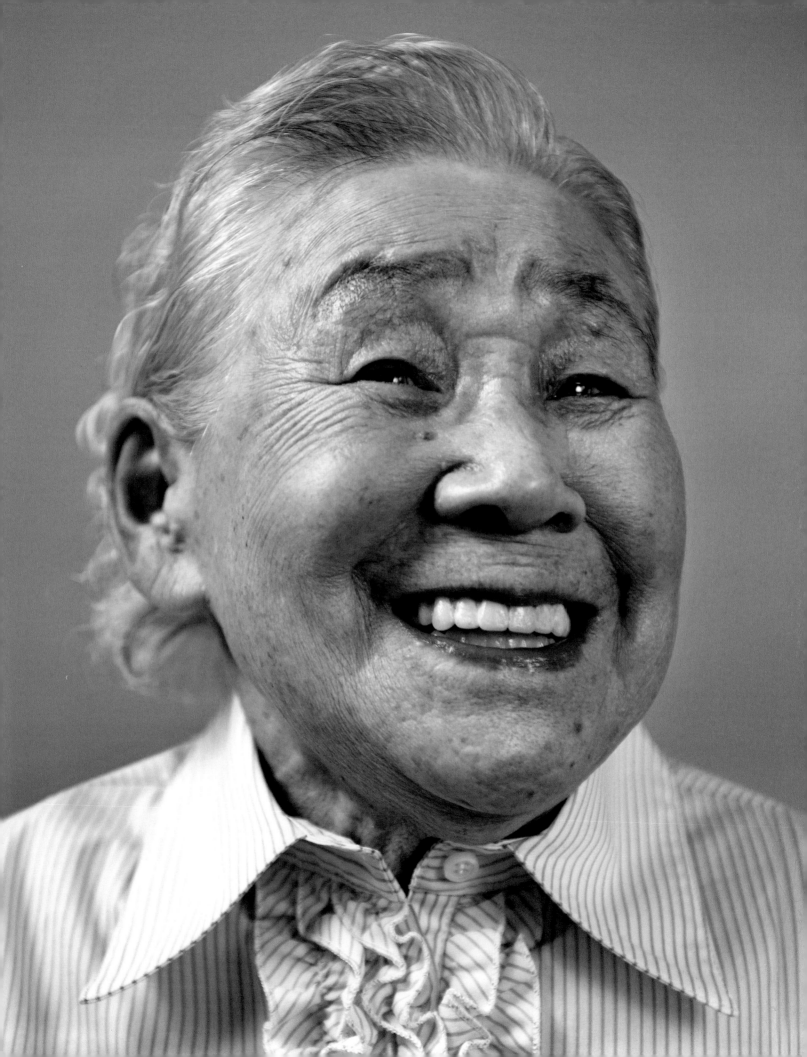

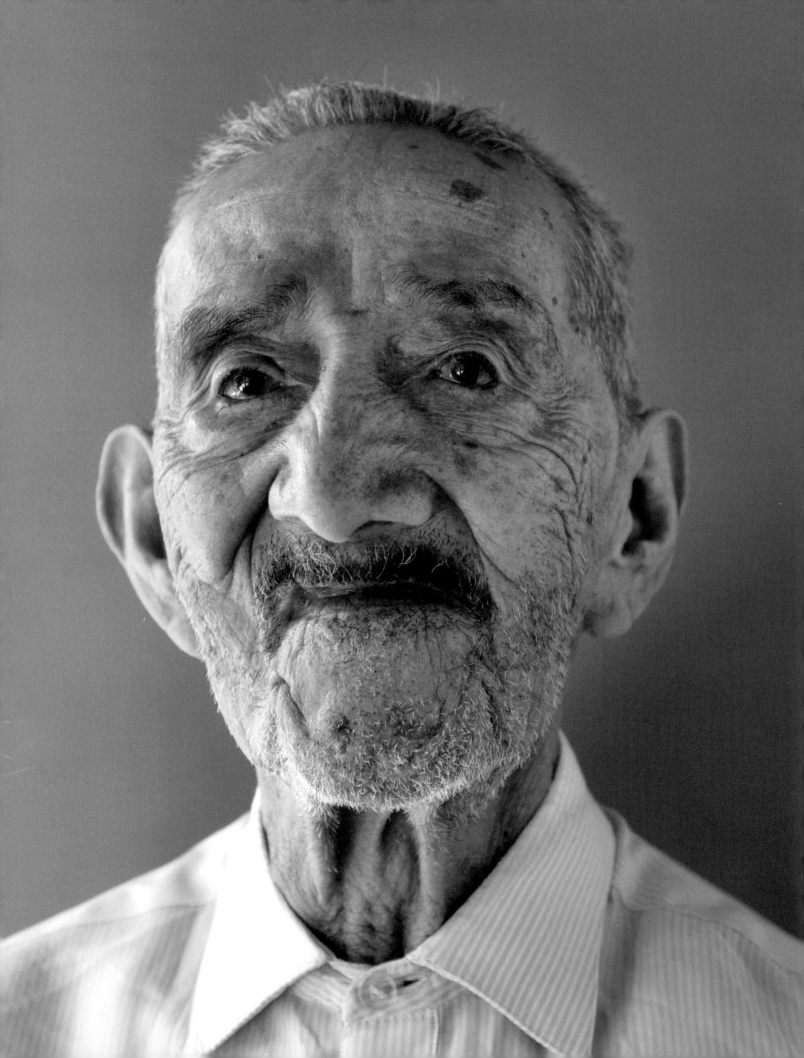

# Secundo Timoteo Arboleda Hurtado

VILCABAMBA, LOJA PROVINCE, ECUADOR

---

Timoteo cares a lot about his health, which is why he stopped smoking at 100. After all, 100 is not old. Not where he lives. Vilcabamba is a Latin American Shangri-la; it was recently named "one of the most healthy places on earth" by the American magazine *International Living*. That's probably because the older generation still practices the same thing Timoteo recommends for a long life: "I eat what I grow!" He harvests everything that appears on his table with his own hands: avocados, papayas, oranges, limes. No pesticides, no preservatives. "Chemicals are bad for the health!" he says, which is why he distills his own schnapps liquor. His other suggestion? "Work doesn't kill anyone!" Timoteo has 3 sons, 2 daughters, 18 grandchildren, and 10 great-grandchildren. The man with the cowboy hat can wait patiently for his great-great-grandchildren to come along—because in Vilcabamba, it's not unusual to be around for a very long time.

# Margarete Boers

LÖHNE, NORTH RHINE-WESTPHALIA, GERMANY

---

According to Margarete, a long life is actually quite easy to achieve. You don't need anything more than "low-fat quark cheese and sour pickles." She laughs as she says this because, of course, "no real advice can be given." Old age just happens. Maybe her cheerful nature has something to do with it. Despite some hard luck, she is still able to say that she "had a good life." Part of that was celebrating Carnival every year—she is from Germany's North Rhine-Westphalia region, where embracing the festive spirit of "the Fifth Season" is practically hardwired in people's DNA.

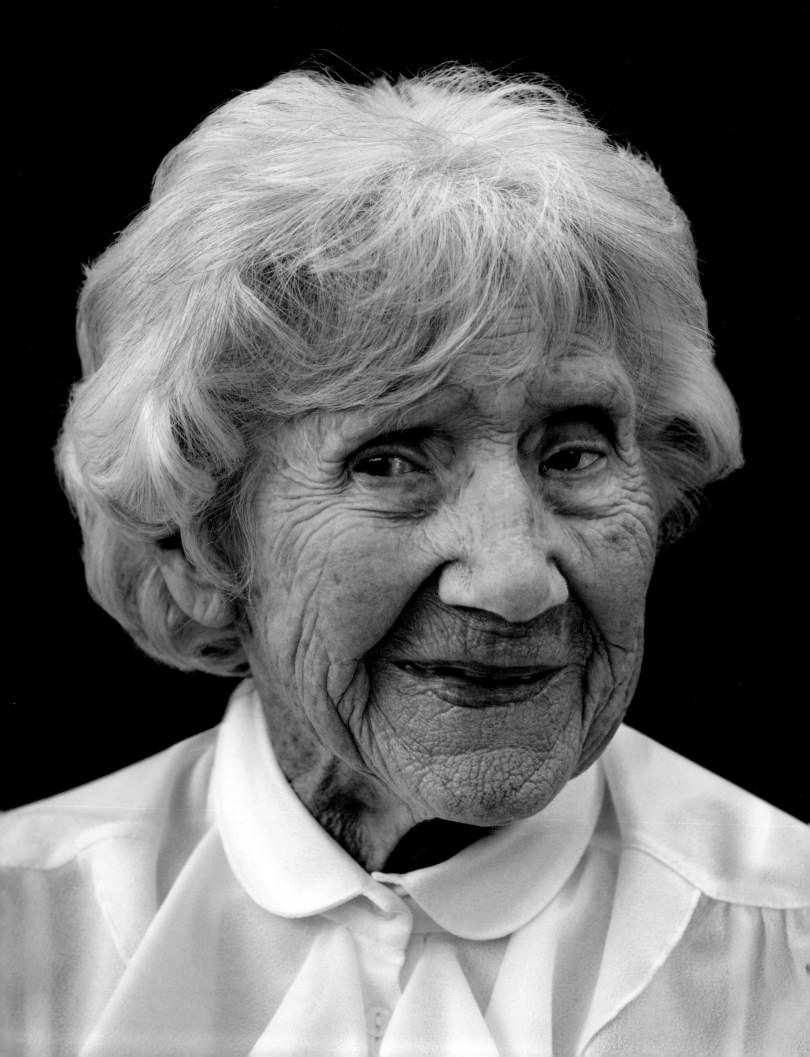

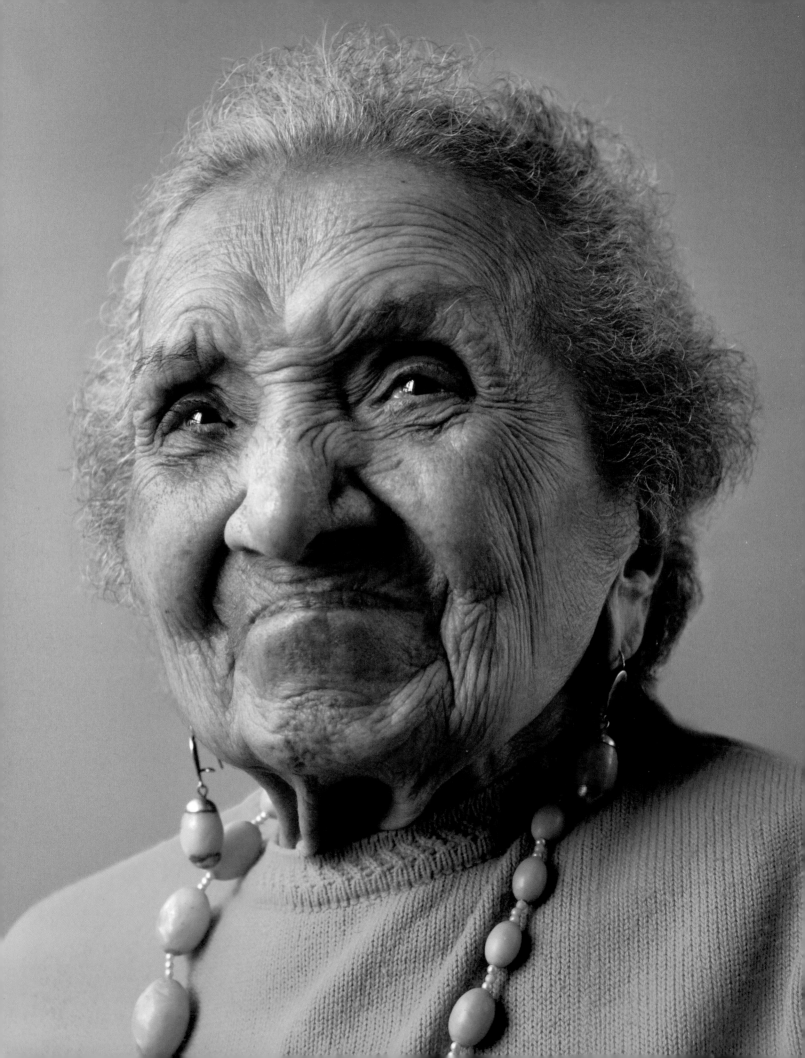

BORN JULY 4, 1913, IN LIMA, PERU

# María Teresa Bolivar vda de Lercari

LIMA, CHORRILLOS DISTRICT, PERU

---

Longevity runs in the family. María's Chilean-born mother lived to be 104. If you ask María what's allowed her to live this long, she says it is above all her positive attitude toward life and a daily glass of red wine—Italian, of course. María has a weakness for Southern European pleasures, including ravioli. It's no wonder— she had a long and happy 39-year marriage to Michele Lercari, a man of Italian descent. She traveled often with him to Europe and visited her favorite cities, Paris and Rome. Although he has been dead for 35 years now, she still misses him every day. But María also says she still has a wonderful life. Today she likes to go for walks with her 80-year-old sister, Consuelo, and enjoys cooking. Her advice to young people: "Never go to extremes!"

# Don Giovanni Carta

ILLORAI, SASSARI PROVINCE, SARDINIA, ITALY

---

Don Giovanni lived in Brazil for nearly half a century, where the Catholic Church sent him as a missionary. He returned to Sardinia in 1995 with Sister Rosa, who kindly looks after the priest even today. Despite his age, he still reads the mass every day in his house in via San Pietro in Illorai. He believes that God has gifted him with such a biblical old age so that he would have the chance to worship Him for longer. And to those who wish for the same, he recommends that they "follow the path to the truth!"

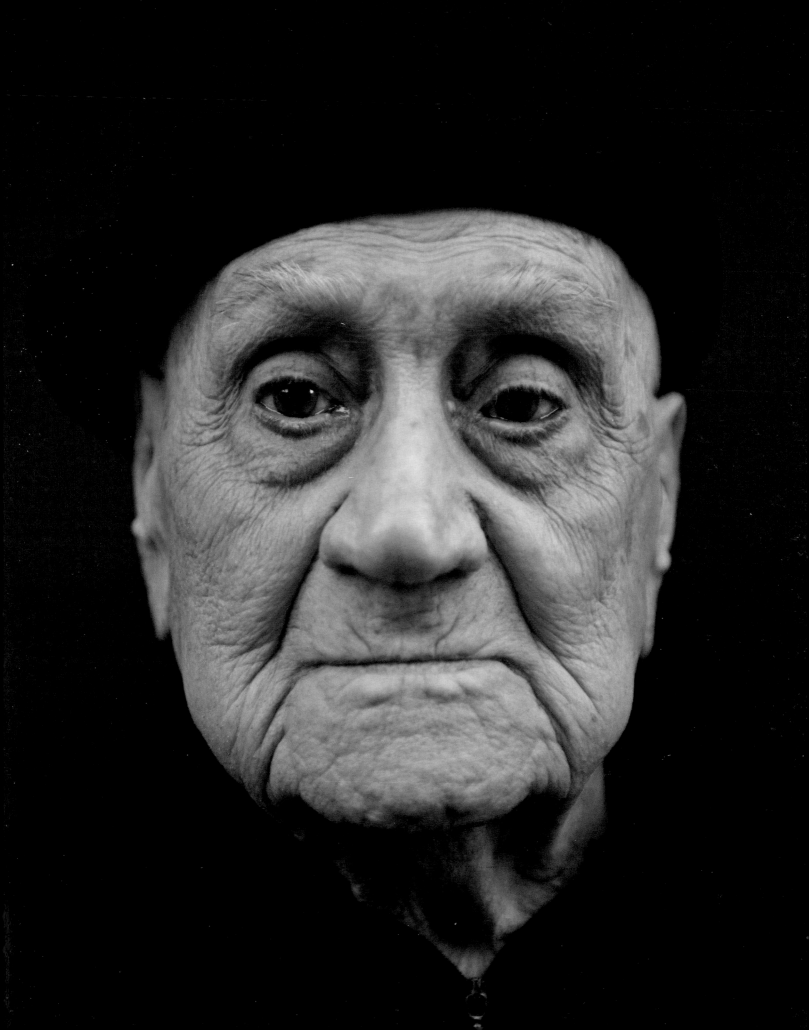

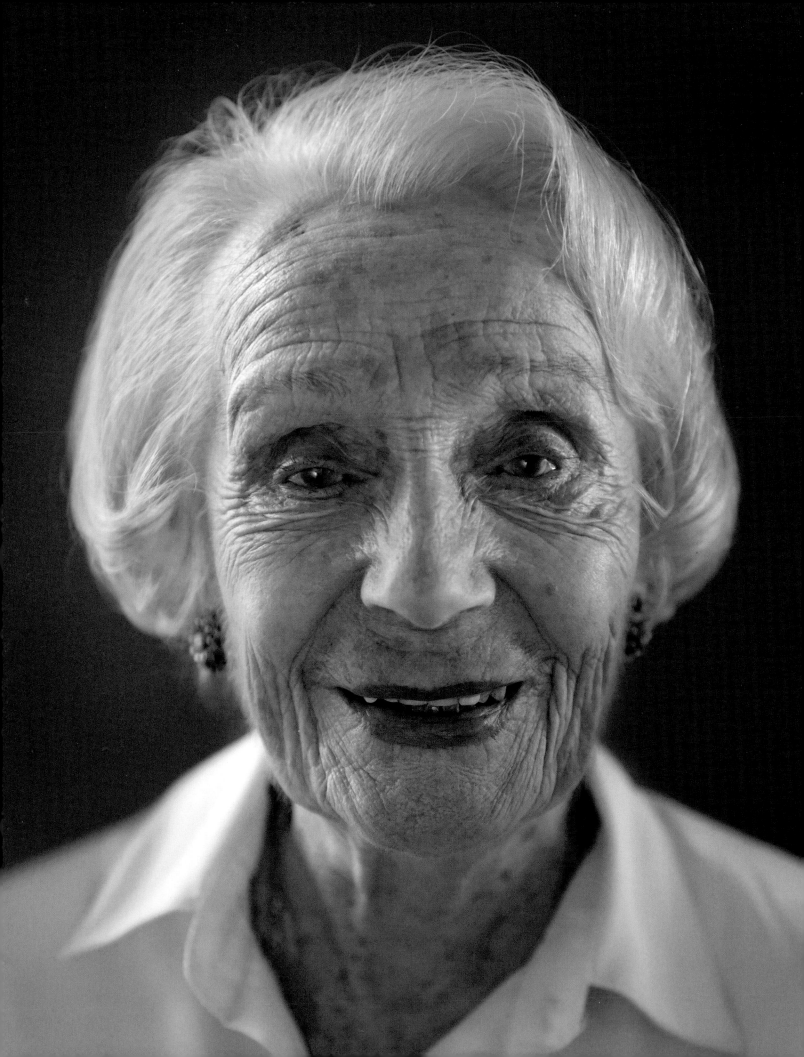

BORN JUNE 14, 1914, IN PARIS, FRANCE

# Gisèle Casadesus

PARIS, FRANCE

---

Gisèle still has the enchanting look of a young girl when she rubs her eyes in astonishment and disbelief at how quickly 100 years have flown by. It's no surprise time passed so rapidly with her full schedule. The French movie star acted in her first role in 1944 and became quite well known in the 1970s. Once things grew a bit quieter for the actress, who still lives in the same apartment where she was born, she was rediscovered at the tender age of 96 with the international success of *My Afternoons with Margueritte,* in which she starred opposite Gérard Depardieu. Gisèle is currently filming again and writing a book about her life in Paris. Artistry must be in her genes: Her father was a composer, her oldest son is an internationally renowned conductor, her daughter is a singer and actress, and her grandson is a successful photographer and documentary filmmaker.

# Henriette Rosa-Maria Cathala

PARIS, FRANCE

---

"With a life like that, you'll never find a husband and won't have children!" Henriette's mother warned her when the former hotel staff manager traveled the world, stopping in places she liked along the way. Traveling has always been one of Henriette's passions. Her last trip abroad was to Australia in 2001, and she still dreams of seeing Panama or Peru, to visit Machu Picchu. "But I'm afraid that the airline won't let me on board unaccompanied at my age." Once a week her grandniece Cécile, who lives close by, takes her out for lunch or dinner, and she has a nurse and domestic assistant who come by a few times a week. She manages everything else herself. She walks around Paris's Place de la Nation every day (regardless of the weather), shops for fresh food at the market, and picks up lunch at a deli. Her mother was right: She never married and has no children. Though she does have remarkably smooth skin. Her beauty secret? "No husband, no children, no problems," she says with a smile.

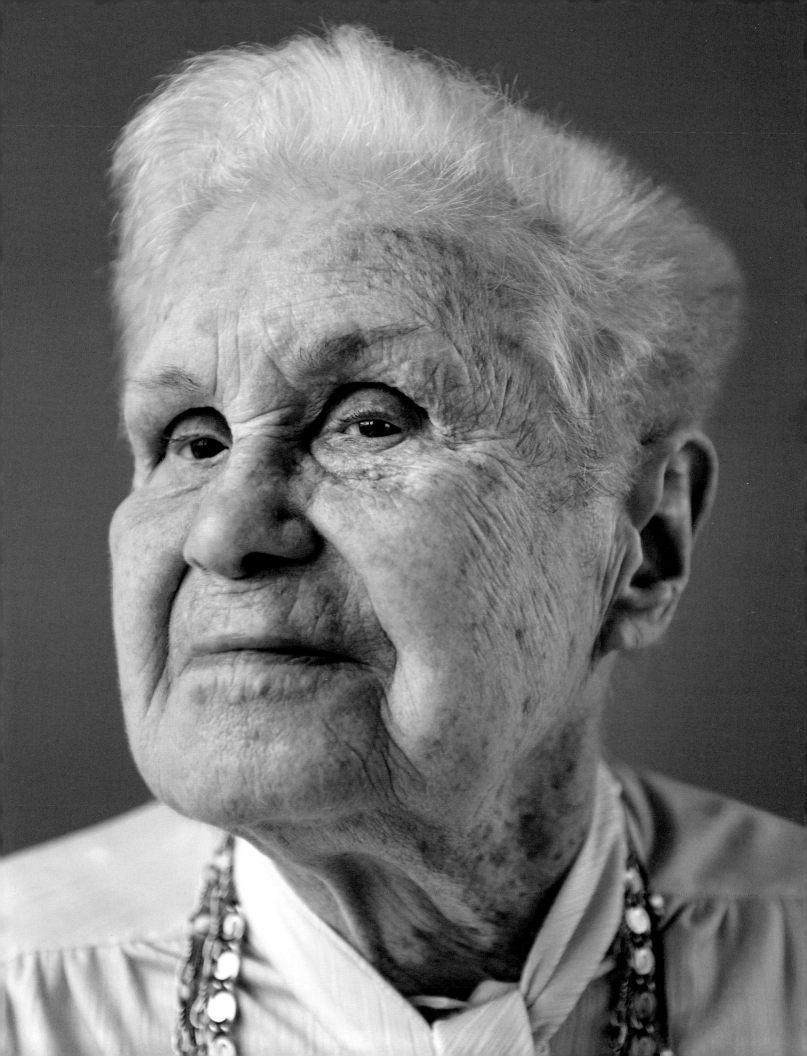

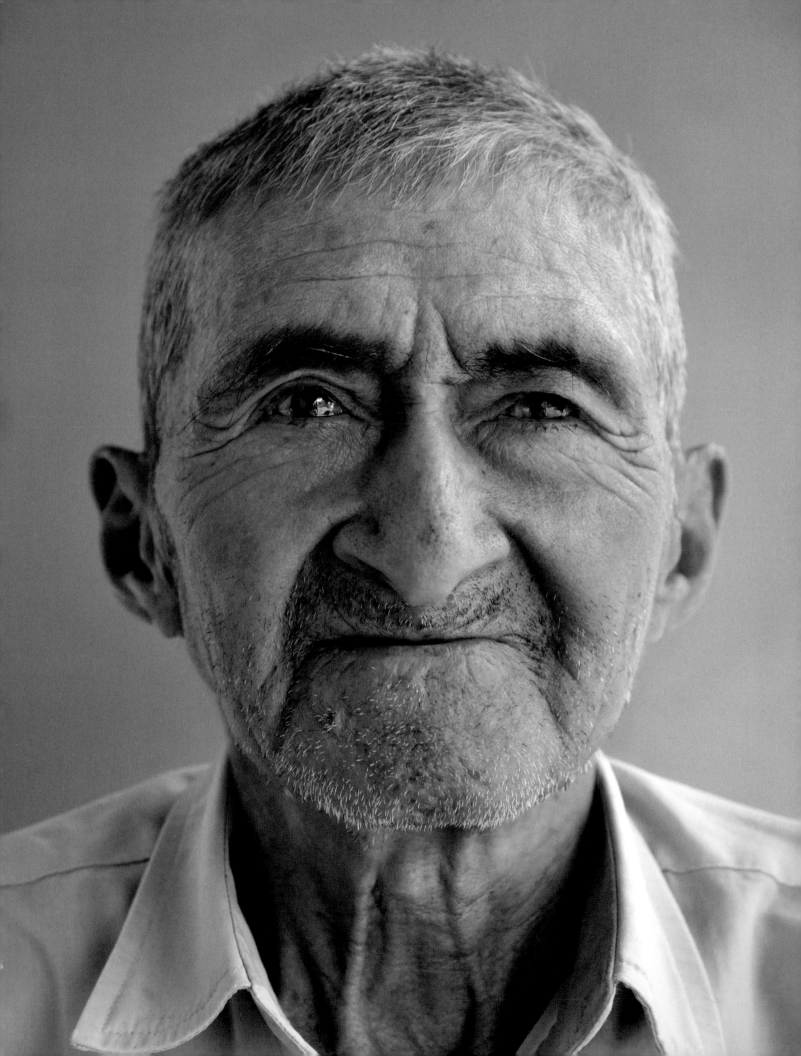

# Jose Javier Delgado Jaramillo

TUMIANUMA, VILCABAMBA, LOJA PROVINCE, ECUADOR

---

Jose and his 89-year-old wife, Mercedes, are the main attraction in the tiny village of Tumianuma in Loja Province. As the oldest inhabitants of the village, a mural was painted in their honor in the small local church, and film crews and photographers come regularly to visit them. Jose and Mercedes take off their baseball caps for the out-of-town visitors. They have been married since 1942 and have nine children, six of whom are still living. They have "around" forty grandchildren, thirty great-grandchildren, and "most certainly one great-great-grandchild," says Mercedes, after some thought. They get up every morning at five, then Mercedes prepares breakfast for her husband. Later they work in the field, gathering manioc, sweet potatoes, beans, corn, and bananas for Jose's favorite dish, *repe* (green banana soup).

# Serafina Eichenhofer

LUCERNE, SWITZERLAND

---

"Serafina" comes from Hebrew and translates roughly as "angel." "That's why the children always looked at me so warily during Sunday mass," she says with a smile. The former athlete still trains on an exercise bike in the foyer of her retirement home, Unterlöchli, and is already looking forward to taking advantage of the new gym that will soon open. She is also an actress—she appeared with six other Unterlöchli residents in the play *Wetterleuchten* ("Summer Lightning") at an open-air festival.

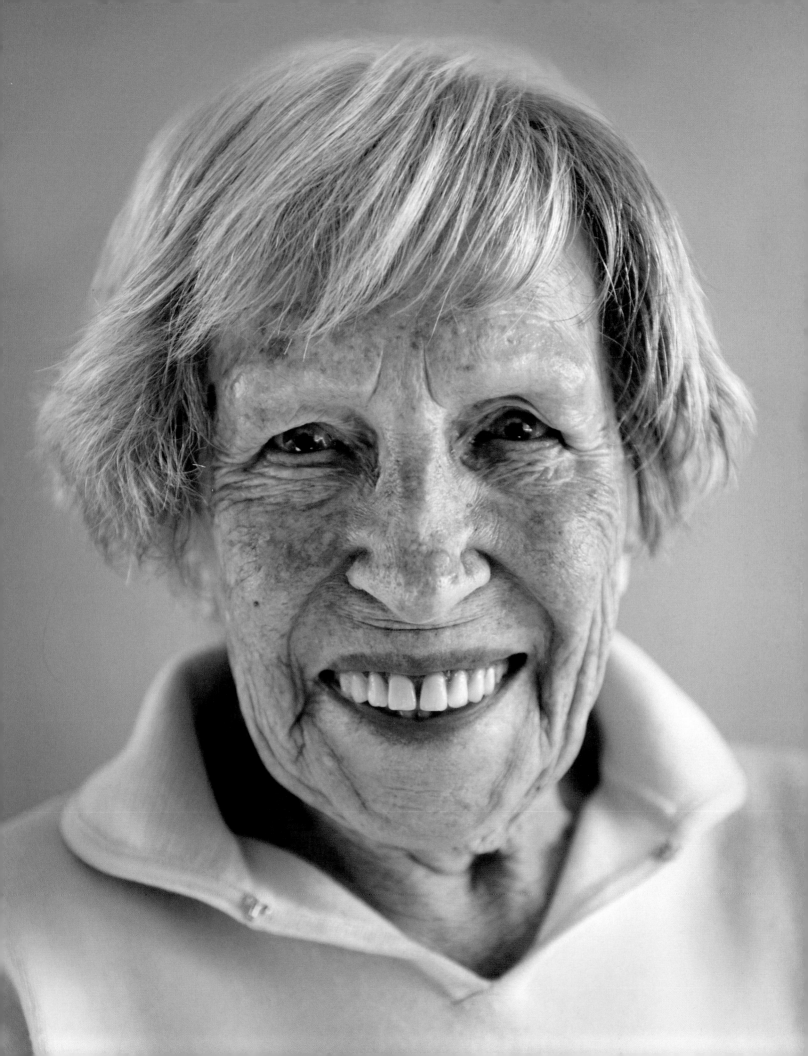

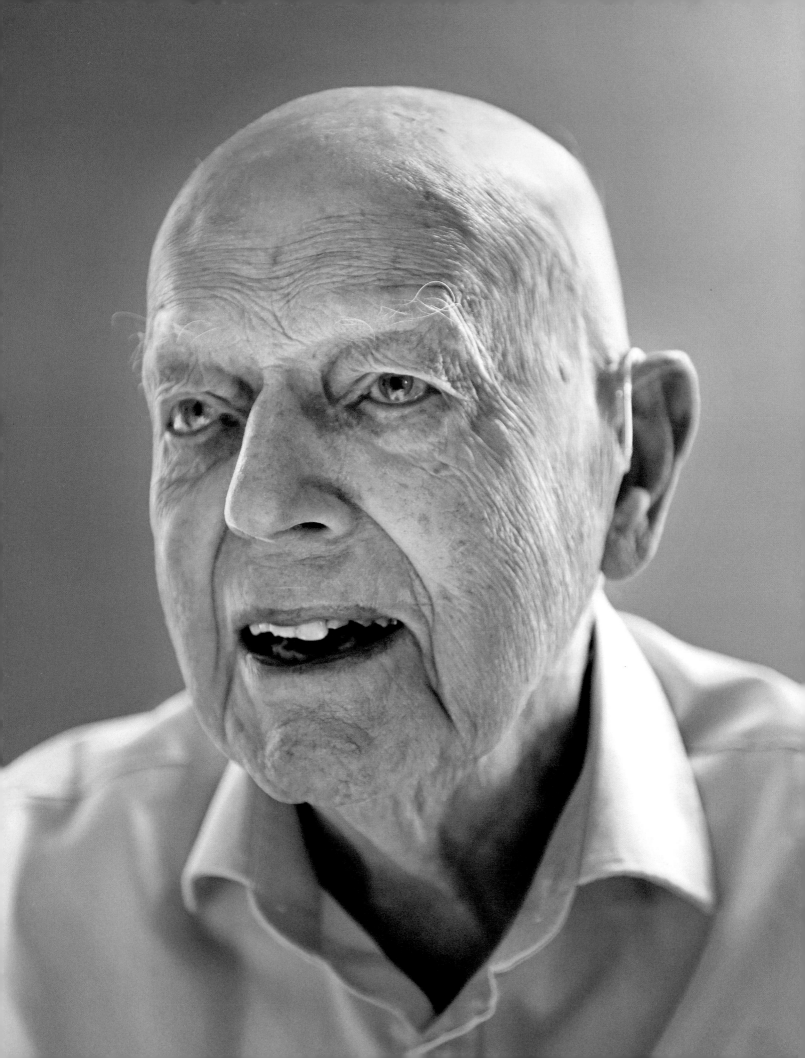

# Carl Falck

OSLO, NORWAY

---

"How do you make any money by photographing old people like me?" That was the first question the oldest resident of Norway asked during our lunch together with his son at Oslo's oldest restaurant, Engebret Café. The restaurant is an institution—as is Carl Falck, the legendary Norwegian manager and lawyer. Falck is still in tune with the latest developments in the business world, although he doesn't like to listen to the news anymore. He prefers to take short walks every two hours, every day. "Old people should walk as much as possible," he says. He was married for 70 years before his wife died at the age of 93, in 2010. The couple had three children, five grandchildren, and three great-grandchildren.

# Karl Otto Götz

NIEDERBREITBACH-WOLFENACKER,
RHINELAND-PALATINATE, GERMANY

---

A visit to the artist couple Karl Otto Götz and Karin Götz—his
second wife and 24 years his junior, to whom he has been married
since 1965—is always an adventure. For over 40 years they have
been living at the end of a dead-end street in a remote village in
Germany's Westerwald region. Karl Otto had planned to become an
engineer in the textile industry, but instead turned to art. Today he
is considered to be the most successful and influential German art
professor since the end of World War II; Gerhard Richter and Sigmar
Polke were among his students. He is one of the inventors and most
important members of the 1950s' abstract painting–style movement
known as Informel. When I visited Karl Otto for the first time, he was
sitting in his darkened living room—surrounded by his large-format
paintings—listening to Duke Ellington. Although he's almost blind,
he still paints. One hundred copies of his work *SiKri* (a combination
of "seven"/"SI-eben" and "circle"/"KRI-ngel"), which he produced
exclusively for his 100th birthday, sold out in a matter of hours.

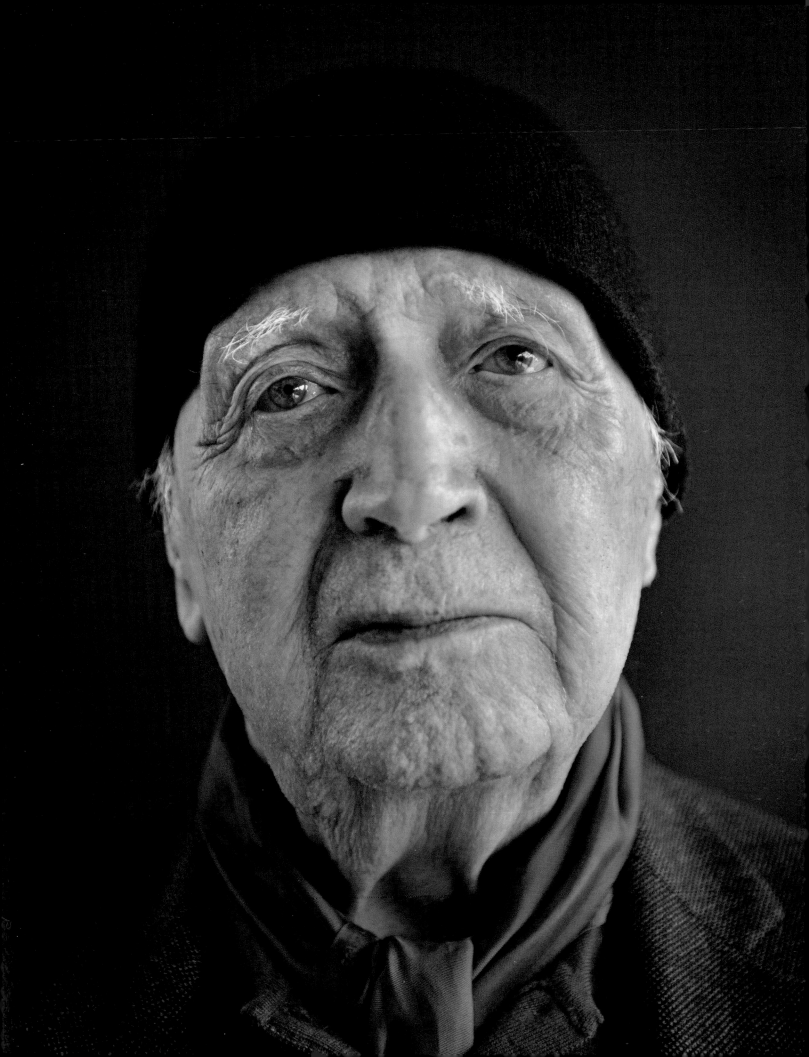

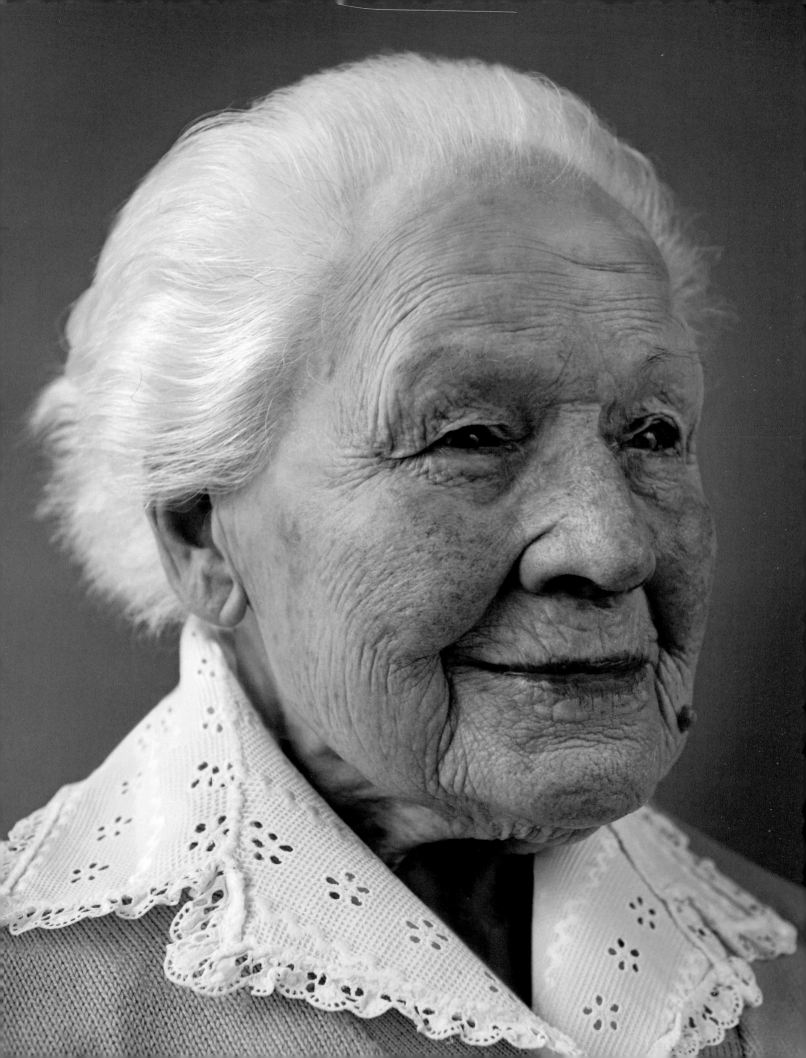

# Aline Grosjean

GÉRARDMER, VOSGES, FRANCE

---

Aline's sweetest memory is of the day she graduated from junior high school and was the only one of six children to receive the grade "good." Even her father, who did not often show his approval, praised her. At 14, Aline began work as a hairdresser, married her boss in her early 20s, and bore three children: a daughter and two sons, one of whom died at the early age of 19. She says that she didn't really do much to become so old. "I think I just have a good constitution." She still likes to knit while listening her favorite music by Johann Strauss, takes care of the roses in the garden, and watches TV—especially reports, animal documentaries, or the regional channel of Alsace, where she has spent her entire life.

# Guðríður Guðbrandsdóttir

Now that we have come all the way to visit her, she couldn't possibly turn us away, she tells us coyly. Guðríður enjoys being an extraordinary phenomenon. Not only is she the oldest inhabitant of her retirement home, Hrafnista, but since 2011 she has also been the oldest woman in Iceland. She has lived in the facility for almost 40 years, mostly alone. Her husband, whom she met while working on a farm, died at just 78, shortly after they moved to the nursing home in Hrafnista. The middle child of 11 siblings, she was a something of a local star when she was a child thanks to her amazing abilities as a storyteller. The couple had no children of their own, but they adopted a daughter and raised two foster children. Guðríður has survived all three of them. Even if her eyesight is no longer what it was, her mind is still sharp. She listens regularly to the news, recites poetry, and has just learned how to crochet. Her recipe for a long life: "Always think positively, don't smoke, don't drink, don't dwell on bad thoughts, don't waste time brooding, and go for a walk every day!"

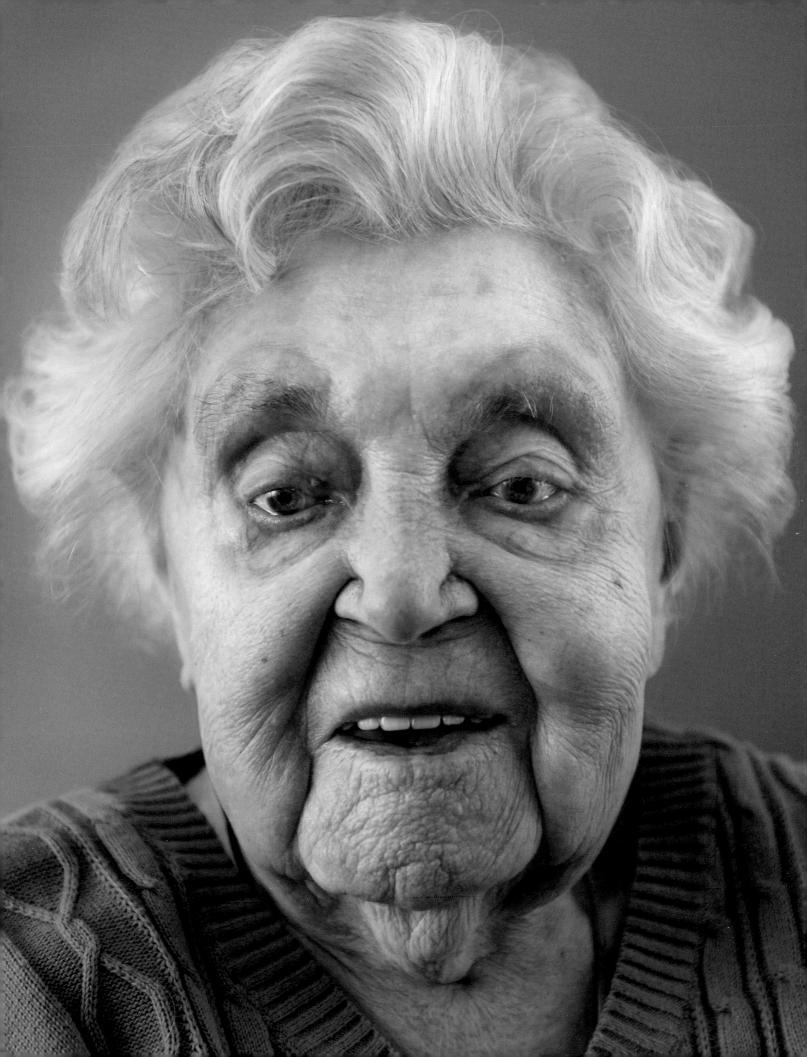

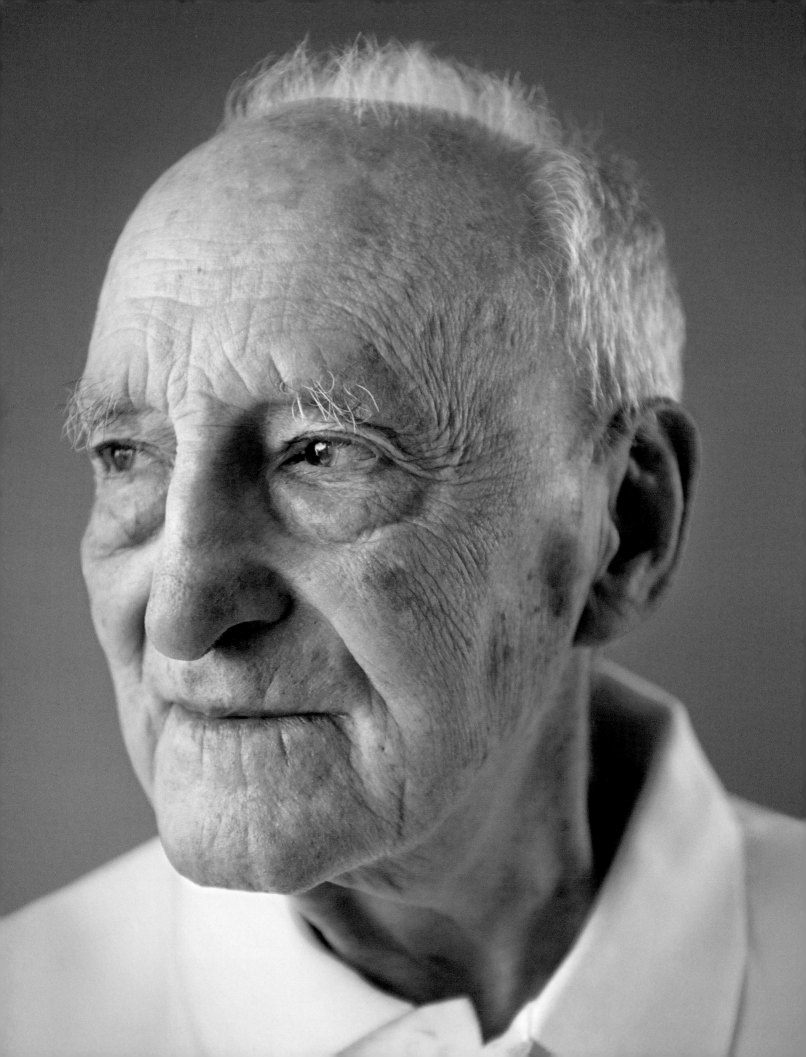

# Lucien Hanoun

VITRY-SUR-SEINE, VAL-DE-MARNE, FRANCE

---

Lucien is still mostly able to provide for himself in his apartment south of Paris, surrounded by photos of family, friends, and companions. Formerly a French teacher, he has a checkered past that began with his birth in a small village in Algeria. He became politically active while still a university student in France, and participated in major demonstrations in favor of paid vacation time, anticolonialism, and finally Algerian independence, which landed him in jail for four years. He has been a member of the French Communist Party for nearly 80 years. Lucien still keeps up to date by reading nonfiction books about politics. He is a passionate, unconventional thinker with a sense of humor. "Centenarians of the world unite!" he jokes as we say good-bye, sending us on our way with his tips for a long life: "Stay true to yourself. And always say what you think!"

BORN SEPTEMBER 10, 1914,
IN NAKAGAWA (TESHIO), JAPAN

# Fujie Harada

SAPPORO, HOKKAIDO, JAPAN

---

Fujie was a spirited child who loved to run around in her parents' farm's peppermint fields. As a young woman, the former tailor was trained in traditional Japanese dressmaking before she married. Her parents used to tell her that being wasteful was a sin. That's why she still finishes her plate at all meals—especially the vegetables, like radish and eggplants, which she grows in her garden during the warm seasons on Japan's northernmost island, Hokkaido. In the long and cold winter months, she often enjoys going to the public bath, where she stays in the water for more than two hours washing her hair, which she boasts she never tried to dye.

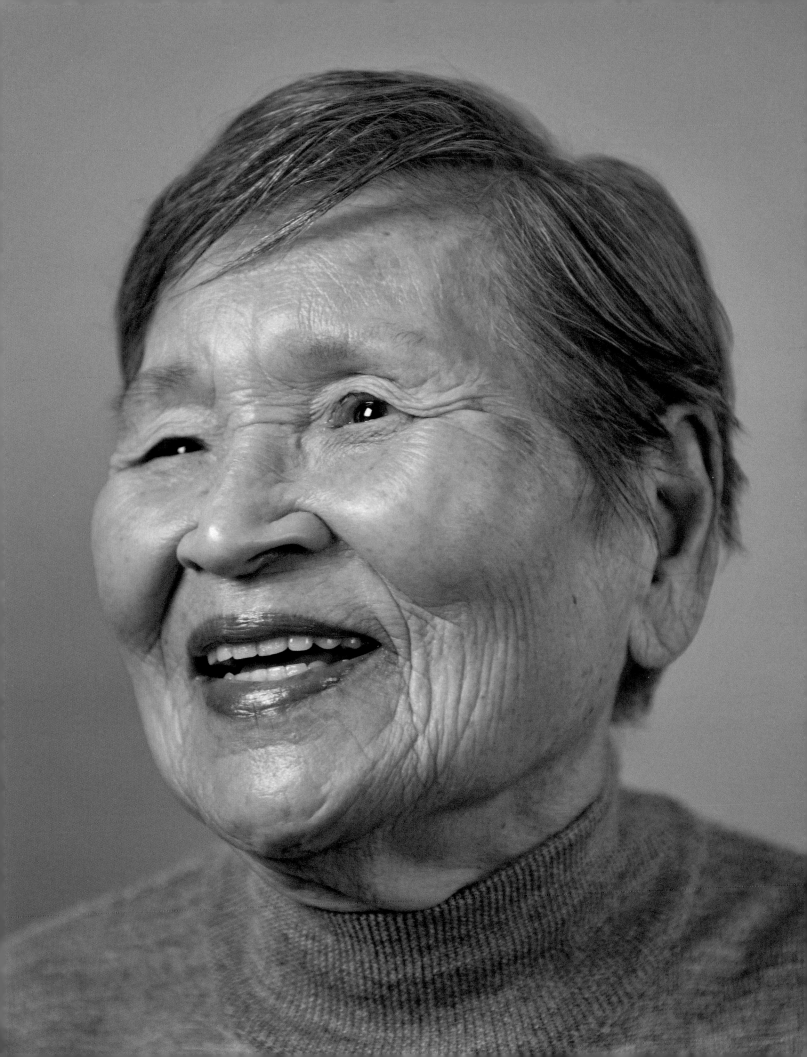

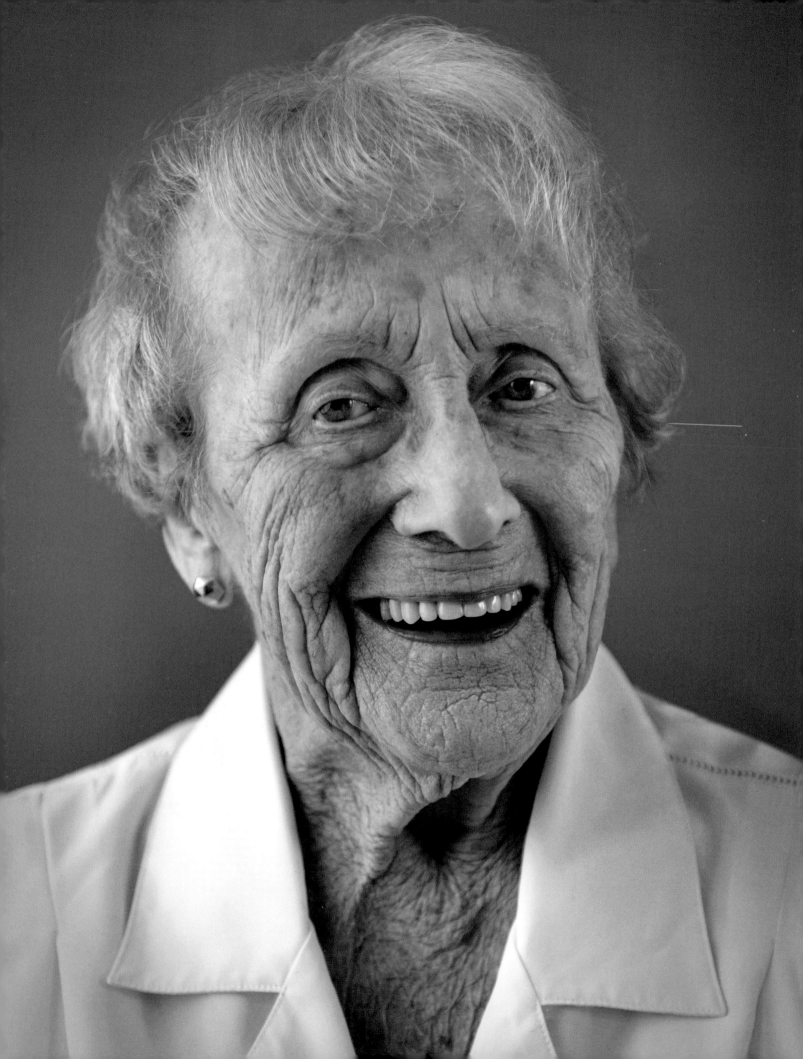

# Annie de Hollander

TOPAZ FORESCHATE, VOORSCHOTEN, NETHERLANDS

---

If Annie were given a pair of wings, she would fly to the German Alps where she used to go skiing so often with her family. Traveling was her passion, as were painting and singing. Today the former housewife leads a somewhat calmer life and takes pleasure in her daily rituals. She appreciates her morning coffee, the newspaper that goes with it, listening to Mozart and Bach, and the fact that she is in good enough shape to keep things tidy herself and to take part in the lives of her five grandchildren. She is proud of her iron constitution and that, on the day of our visit, it was not her daughter-in-law who went with her to see the doctor, but rather she who went with her daughter-in-law to see the doctor. Annie says her longevity may have something to do with the fact that she never smoked and didn't drink alcohol. Instead, she always drank only fruit juice or tomato juice.

# Olivia Hooker

WHITE PLAINS, NEW YORK, USA

---

When Dr. Olivia Hooker was 6 years old, members of the Ku Klux Klan ransacked her home during the 1921 Tulsa race riot. "I still don't know why they bothered to burn up a little girl's doll clothes, but they did," she told the *Wall Street Journal*. "And that's what made me very, very afraid. That was a startling thing for a child. It took a while to get over." Decades later, Hooker joined the Tulsa Race Riot Commission and was among survivors who filed an unsuccessful federal lawsuit seeking reparations. In the 1940s she was one of the first African American women to join the U.S. Army. In 1961 she earned her PhD in psychology from the University of Rochester and worked for a long time with women with learning disabilities. The walls in her tiny house in White Plains, in upstate New York, are plastered with diplomas and greeting cards addressed to her—from the Clintons, the Bushes, and the Obamas.

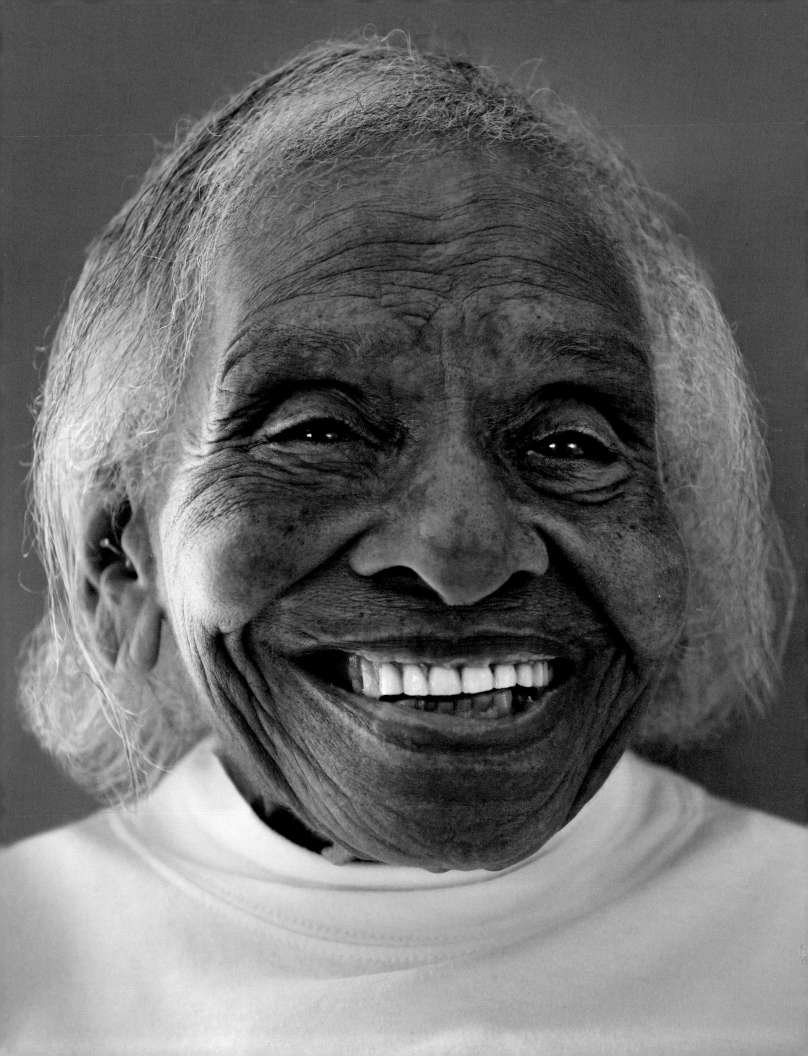

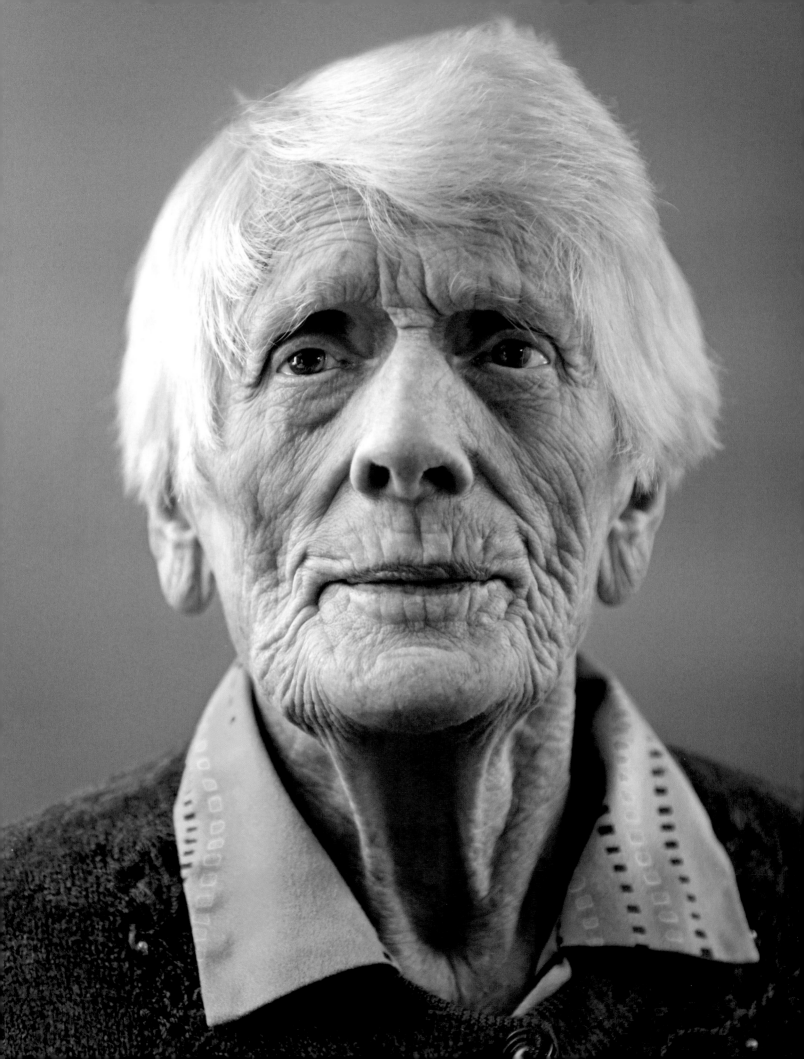

# Guðríður Jonsdottir

HRAFNISTA, REYKJAVIK, ICELAND

---

Despite losing her sight 15 years ago, Guðríður laughs a lot and tries to "have a good time and lead a happy life." In her opinion, these are the three pillars for becoming very, very old—as well as this tip: "Do whatever you want!" The former farmer, who enjoys Icelandic accordion music and singing at church, was married to a fisherman. He was the best thing that could have happened to her, she says, and not just because of his "amazingly beautiful blue eyes." Although she did not fall in love with him quite as quickly as he did with her, the couple eventually had three children. Guðríður doesn't really know how many grandchildren she has— but she remembers that she has traveled to Germany and Italy.

# Sigurgeir Jónsson

REYKJAVIK, ICELAND

---

Sigurgeir Jónsson says he doesn't really know why he grew so old. He had quite a tough life on the whole. He grew up on the island of Flatey and worked as a bricklayer. "On the construction site we had often dried fish with butter for lunch. Maybe that's why I'm still alive. Or because the heavy lifting and carrying has kept me fit! I think you just have to pay attention to your health and avoid eating sweets," he says. He and his wife, who died in 1994, had no children, but he doesn't feel alone. "I sing with others. That makes me happy."

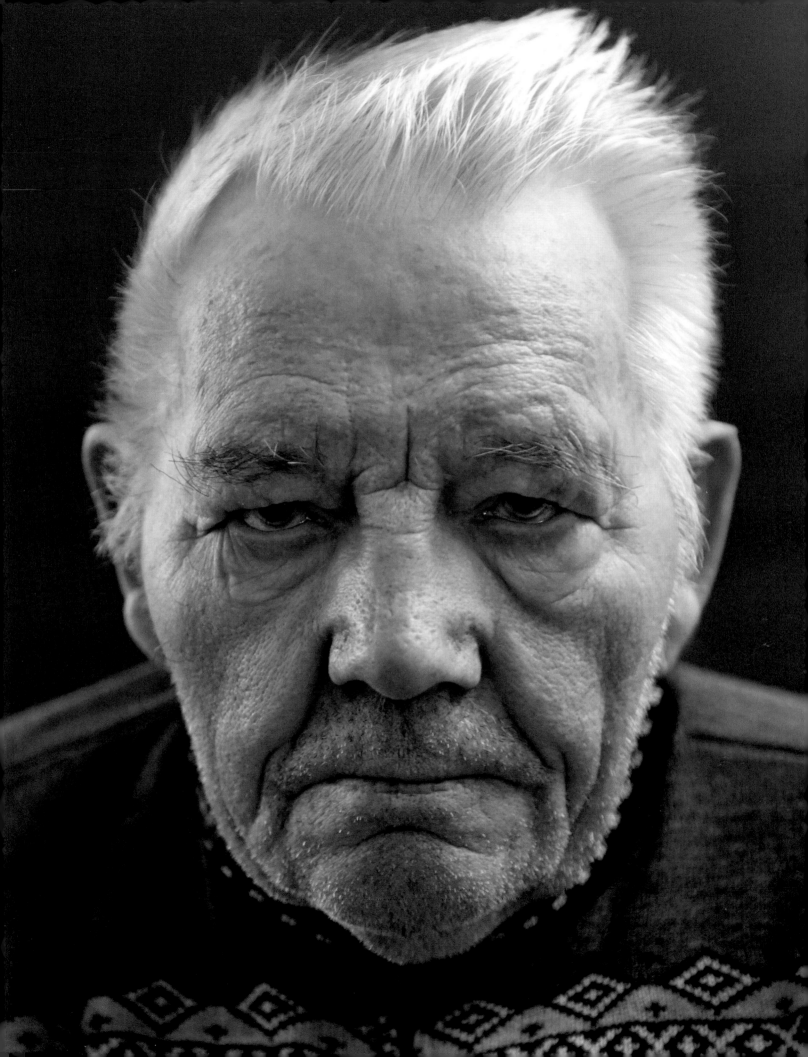

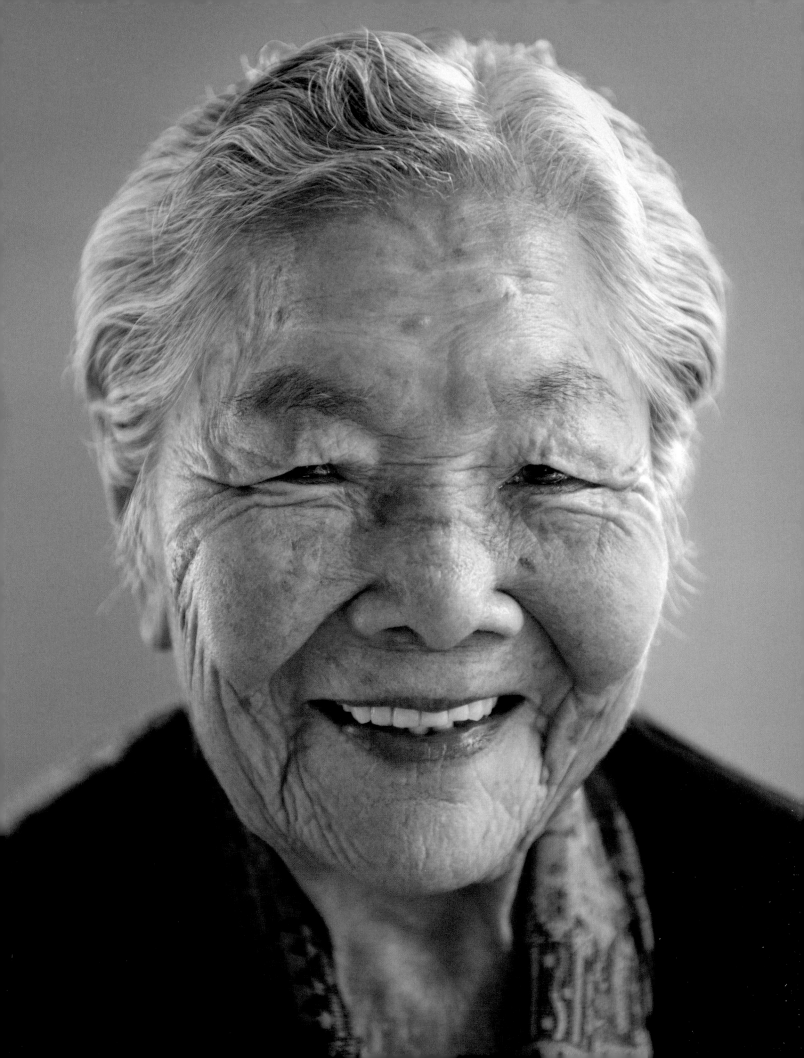

# Miyagui Kami

ŌGIMI, KUNIGAMI DISTRICT, OKINAWA, JAPAN

---

Miyagui loves her weekly visits to the senior center in her village, Ōgimi, the so-called "Village of Longevity" in northern Okinawa. She gets a health check and has her blood pressure measured, then she joins the group for gymnastics and singing. Like most people here, Miyagui spent her earlier days farming, out under the open skies all year long. Today she gets pleasure from working in her garden and her house, gambling with her friends, taking tea breaks, and visiting with her great-grandchildren.

# Gerardus Jacobus Johannes Keizen

TOPAZ FORESCHATE, VOORSCHOTEN, NETHERLANDS

---

Gerardus says the best time of his life was when he was working in the Netherlands Antilles for KLM as a traffic manager. He enjoys talking about how, in the event of flight delays, he was responsible for the flight plan and passengers. And he speaks lovingly about his wife, Gertruida, to whom he was married for 66 years until she died in 2011. They have two sons and three grandchildren. Gerardus tugs at his sparse hair and twirls his moustache, getting himself ready for the camera. He likes the attention and that people want to know how he managed to grow so old. After all, growing old is one of the things he does best. "A routine life of moderation. Go to bed early, don't smoke, don't drink—although you can always make an exception now and then for a whisky. And for gin, too."

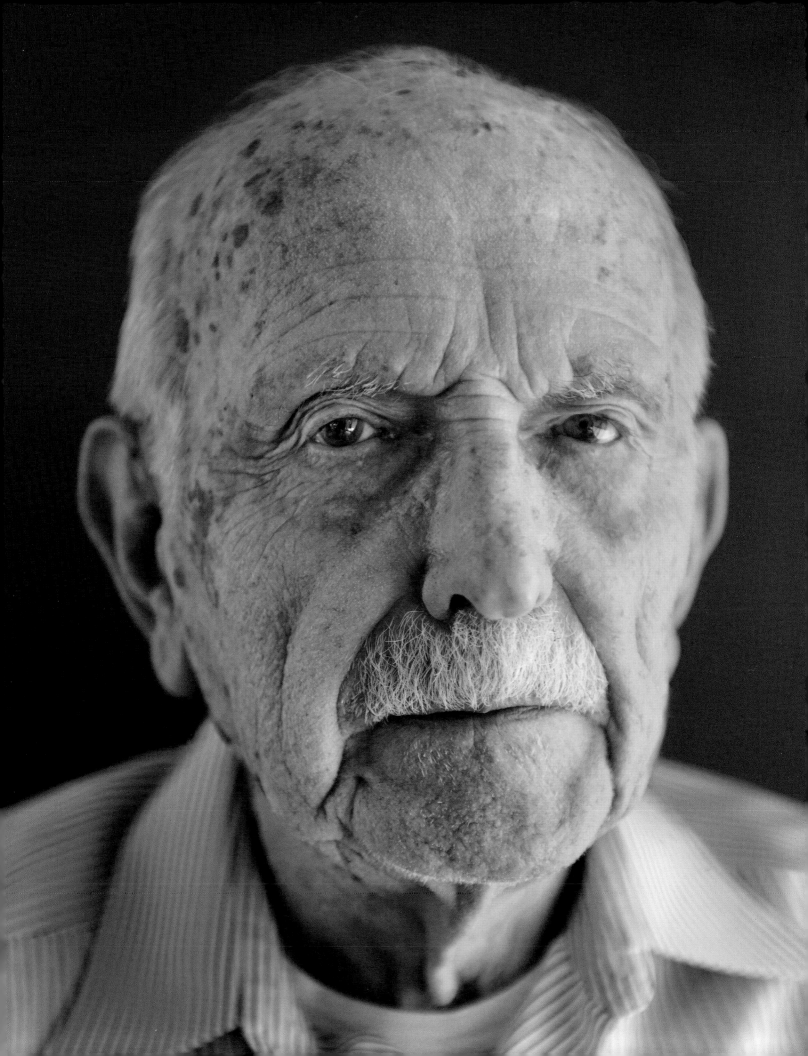

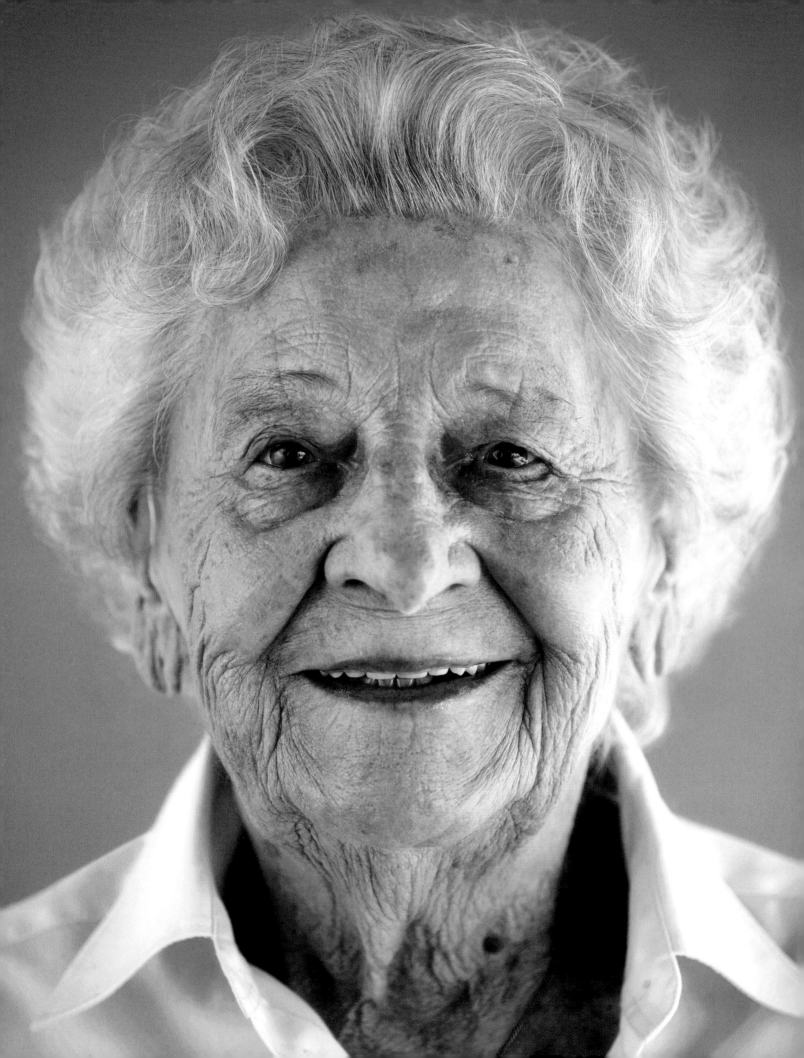

# Paula Klambauer

WELS, UPPER AUSTRIA, AUSTRIA

---

Paula is very trim and barely looks a day past 85 at the most. Trained as a tailor, she has a great appreciation for clothes. Following her own motto, "One is always too young for old fashion," she dresses in the trends for 60-year-olds. "I don't like fashion for 70-, 80-, and 90-year-olds." She has her stepfather, a boiler-maker, to thank for the fact that she learned any trade at all, which was unusual for the girls of her generation. She married in 1939 and gave birth to her daughter, Ingrid, in 1940 and her son, Karl-Heinz, in 1944. She had to raise her children alone during the entire war. Her husband did not return until 1947, injured in body and spirit. After that, she sewed only at home and became a house-wife. "I earned it," she says, laughing.

# Elfriede Kriete

LÖHNE, NORTH RHINE-WESTPHALIA, GERMANY

---

Elfriede can hardly believe it herself that she is so old. "The mind is still fit, only the body is weak." At over 100 years old, it turns out you can still bump into old classmates by chance, as Elfriede did two years ago at a bus stop. It was there that she ran into Margarete Boers (page 22), with whom she used to go to school. Thanks to Margarete, Elfriede now attends regular meetings for the centenarians of the Herford District, which her friend invited her to join. More than 1,000 years of life sat there together having fun. "Even we old people need a bit of love and recognition," says Elfriede.

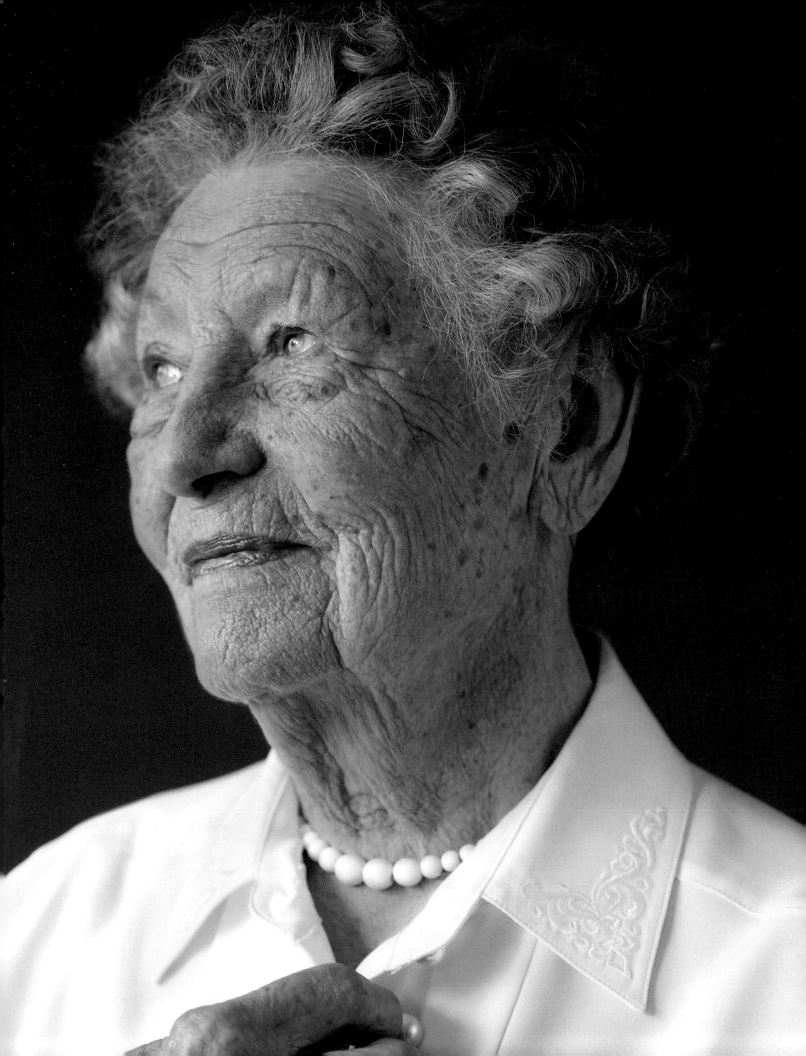

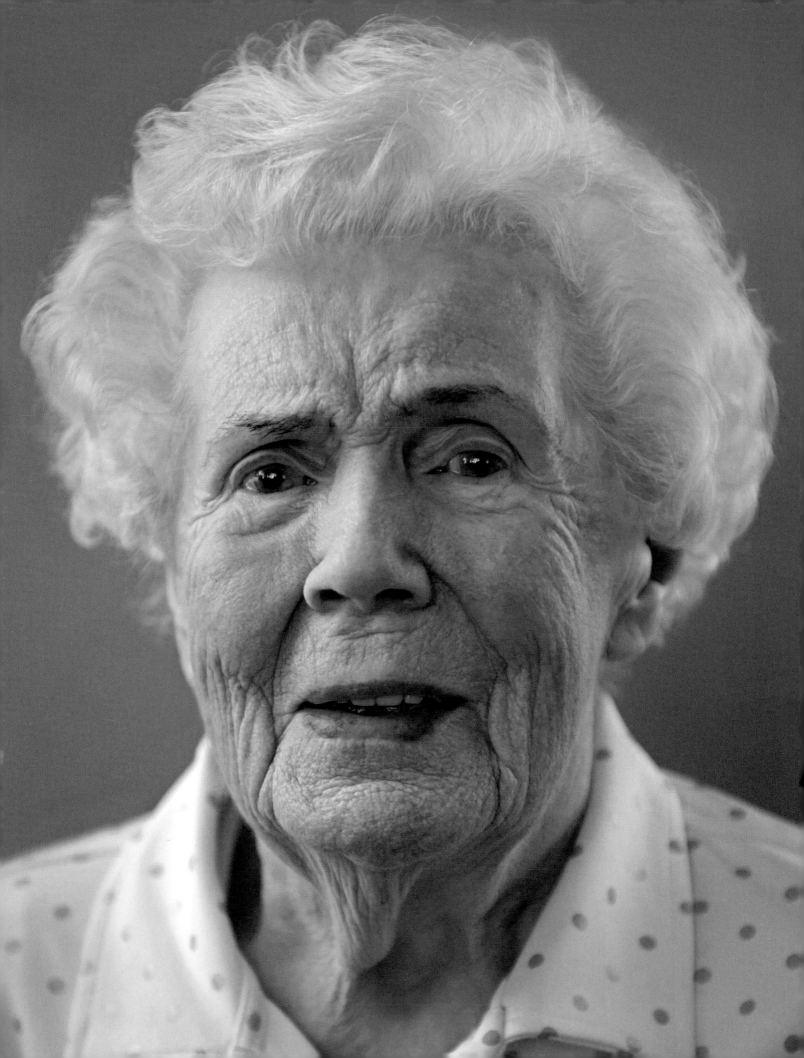

# Kristin Kristvardsdottier

Kristin says that, in her family, it's nothing special to live to such an old age. "Many of my father's siblings made it to over 100." Nevertheless, the former seamstress can't say whether there is any particular recipe for it. "I only know what was important to me: to be modest in all areas of life and to keep physically fit. That is what I practice to this day." Every day after breakfast she goes on the exercise bike, does finger gymnastics, and looks after her four-month-old great-grandchild. "I read a lot, mostly books by Halldór Laxness. I like to listen to music, symphonies, accordion . . . nearly everything except Björk. I know I shouldn't say that as an Icelander. But somehow it's not my kind of music." For this woman with four sons, ten grandchildren, and four great-grandchildren, life is a school in which you never stop learning. If she was granted three wishes, she would have only one: "I would wish that my husband were still here. He was a shipbuilding engineer and died when he was only 61. I was in love just once in my life, and it was with him."

# Gerhard Kübrich

JENA, THURINGIA, GERMANY

---

Gerhard Kübrich got through hard times by earning money in various jobs, including as a banker, a plumber, and finally a lab technician. But his true passion was painting, which he did until only a few years ago, when his eyesight began to decline. For his 101st birthday, the nursing home where he now lives organized an exhibition of his art. The show features a delicate watercolor work he painted in art class when he was a mere boy of 13. He points to a piece of fruit in the painting, "This apple here I had to bring back home from school. Mom wanted me to share it with my seven siblings. Can you imagine how poor we were?"

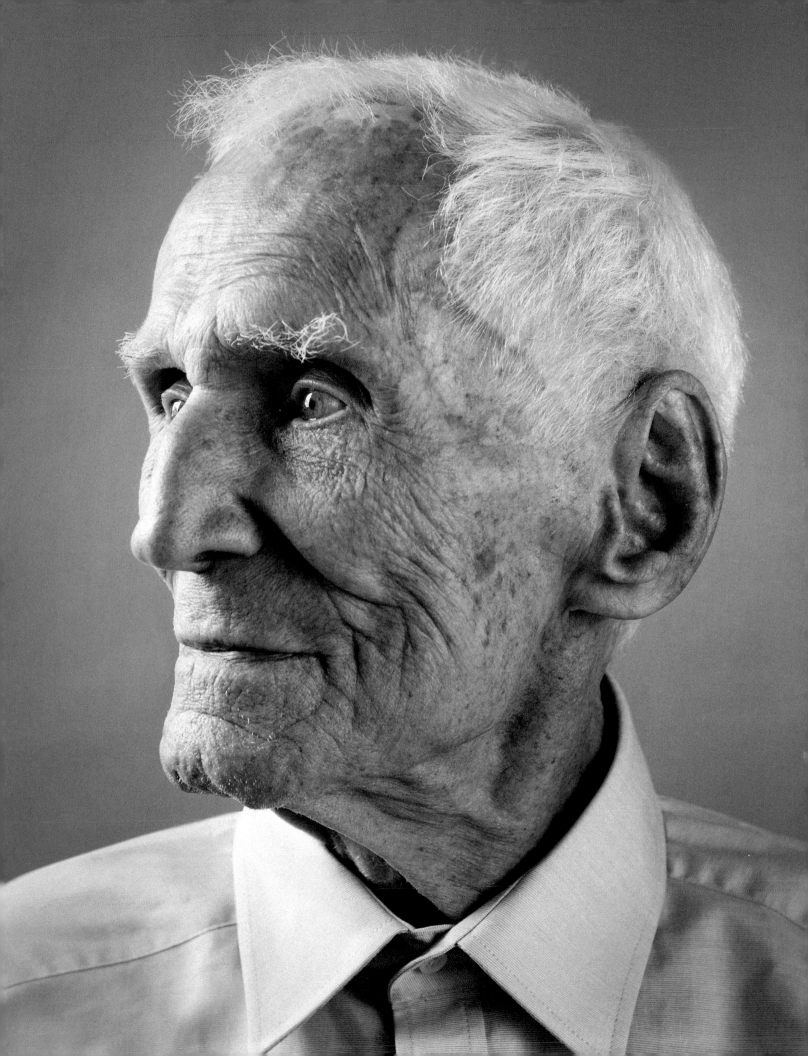

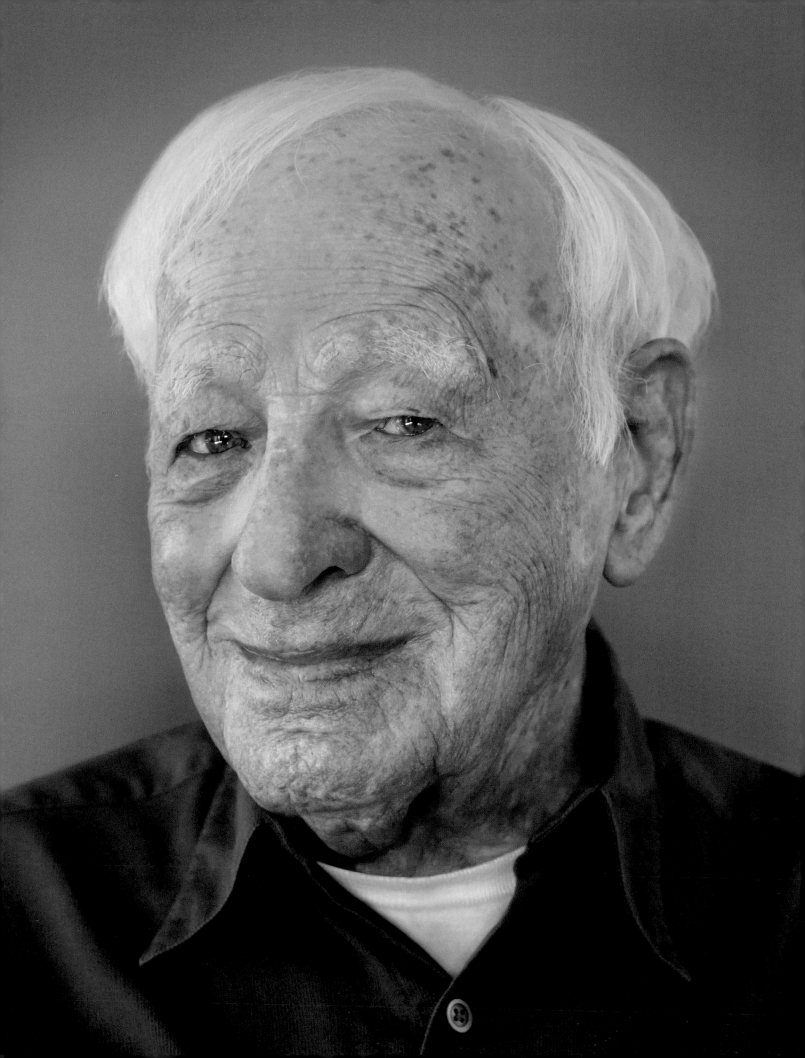

BORN JANUARY 11, 1914,
IN EAST HARLEM, NEW YORK, USA

# Morrie Markoff

LOS ANGELES, CALIFORNIA, USA

---

Morrie started working as a mechanic when he was just 14. After marrying his wife, Betty (page 70), they raised a son and a daughter, and now they have five grandchildren and two great-grandchildren. Throughout his life Morrie has been an artist: a photographer, sculptor, and painter. They called him "Mr. Fix-It" because he was always handy at fixing things. Once while repairing a toilet, he discovered that the float looks like a ballerina's tutu. Inspired, he picked up a soldering iron and his first metal sculpture emerged. He held his first exhibition at the age of 100, in the Chinatown Art District of Los Angeles; another exhibition is in the works. After just a few minutes with Morrie, you can tell that he has never been bored for a single minute of his long and creative life.

# Betty Markoff

---

The secret to Betty's long marriage to Morrie? Listening! And they have listened to each other for a long time—nearly 80 years. Betty first met her future husband (page 69) at her cousin's wedding in New York in 1938. Her friends tried as hard as they could to dissuade her from getting involved with the attractive Morrie. Fortunately she didn't listen and by the end of the year they were married. Like her husband, Betty likes to watch people. She has had ample opportunity to do so since the two of them moved to LA's Bunker Hill, a lively hipster district. The neighborhood is just as worth seeing as the view of the skyline from their spacious apartment.

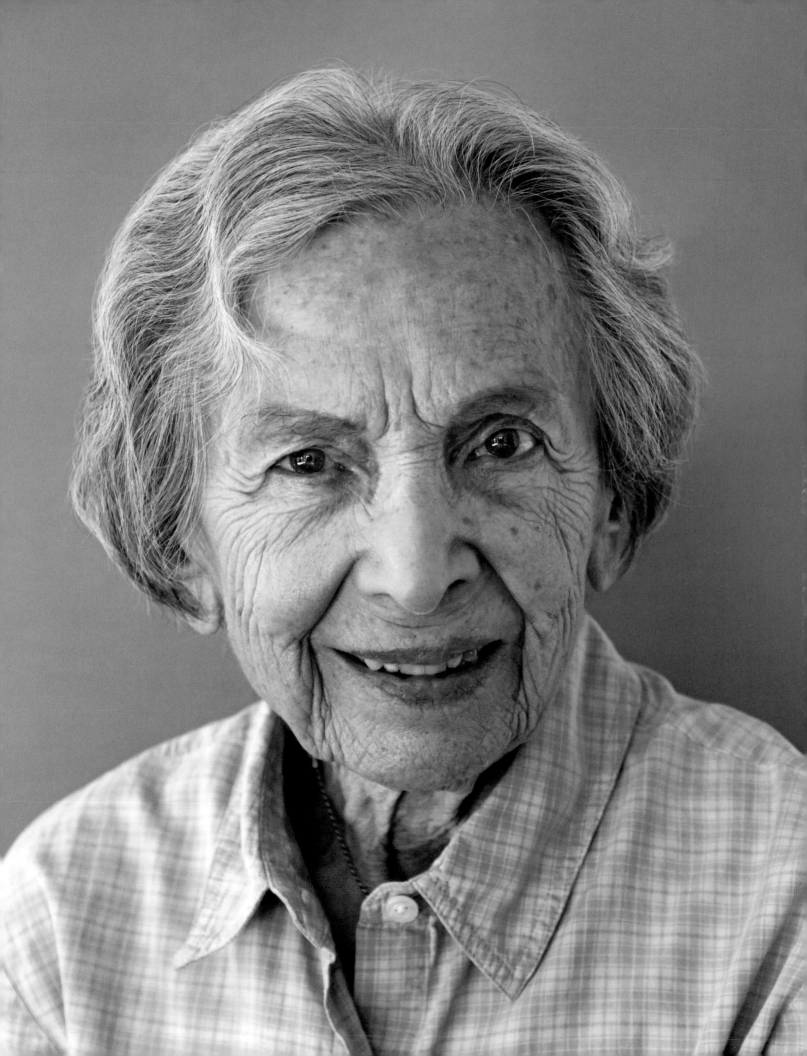

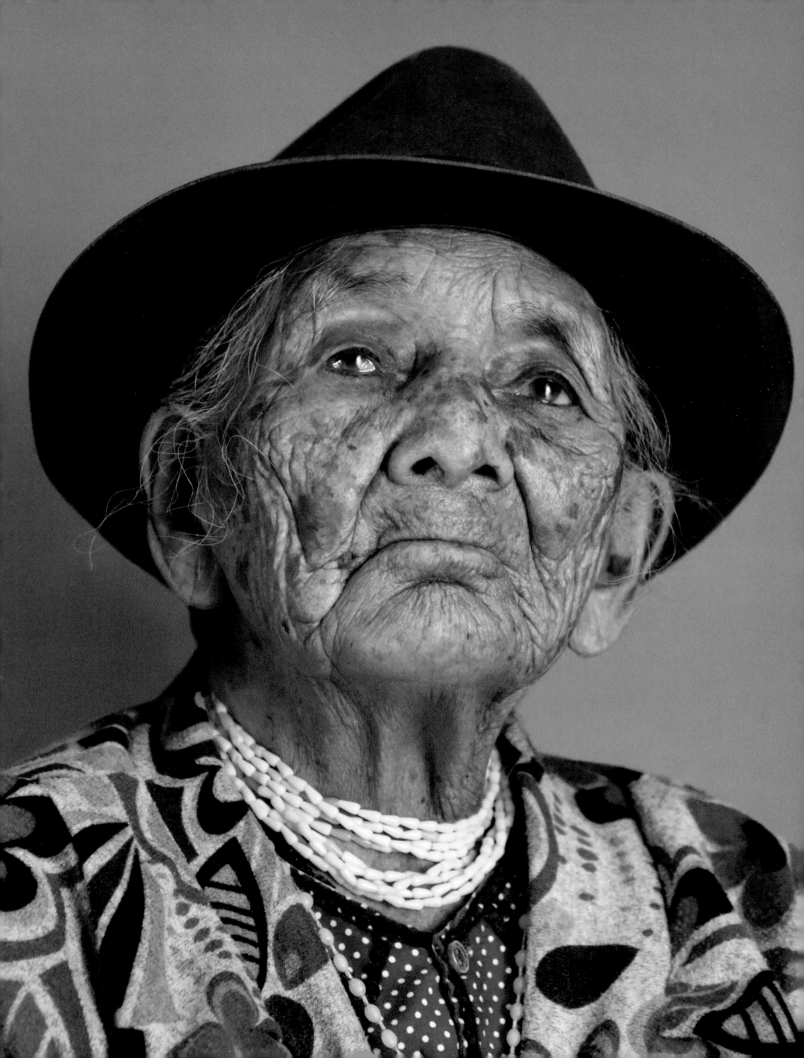

# María Luisa Medina

MOLLEPAMBA, VILCABAMBA, LOJA PROVINCE, ECUADOR

---

María sits on a couple of blankets on the floor in her house and spins yarn out of sheep's wool. This has been her favorite pastime since her legs gave out. The doctor she saw recently, for the first and perhaps last time in her life, could not do anything to help her. In the future, María will turn to her tried-and-true home remedy, *ishpingo*—a brew of eucalyptus leaves, rue, camphor, and other ingredients—as well as rest, fresh air, and the healthy food that grows in the garden behind the house in Vilcabamba, which translates as "sacred valley." It's a simple routine, she says, but "it keeps you tough."

# Gaspare Mele

OROTELLI, NUORO PROVINCE, SARDINIA, ITALY

---

Villagers from Orotelli call Gaspare "Uncle Gasparru." Gaspare, has dedicated almost his entire life to poetry. He still loves to sit in his kitchen and bash soulful, philosophical verses into his old typewriter. And he loves his family. He has eight children (two of his daughters live with him), grandchildren, and great-grandchildren. Fascinated by the literature his father gave him to read in his childhood, he taught himself to write while stationed in Somalia during World War II. Uncle Gasparru's advice for a long life: "Live and work in peace and harmony with yourself and with others. Always try to distinguish good from evil."

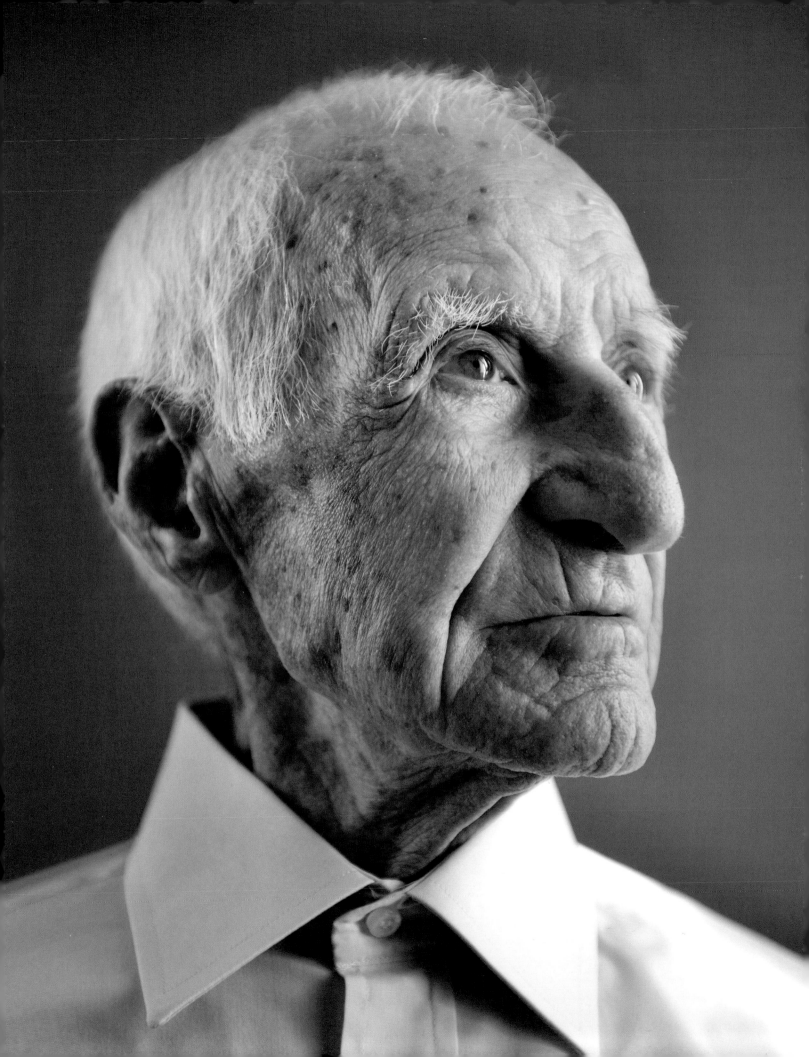

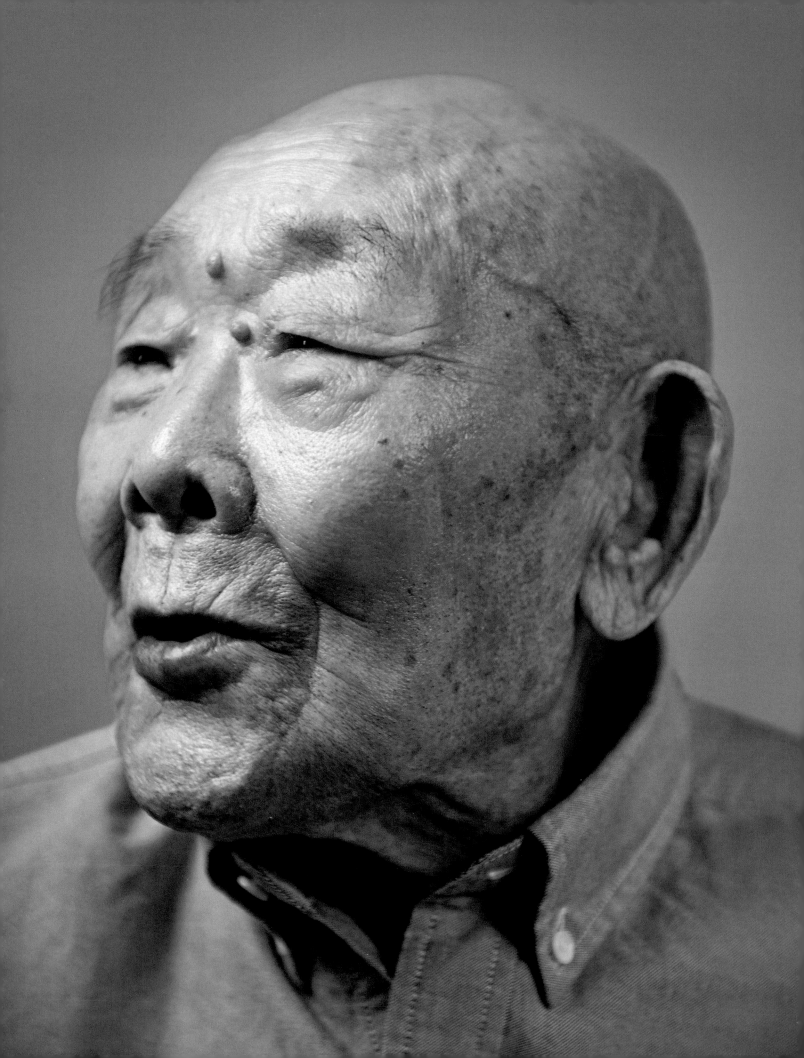

# Kiichiero Nakajima

SAPPORO, HOKKAIDO, JAPAN

---

Kiichiero always seems to be smiling, and he smiles even more
when his grandchildren are around. He smiles despite the fact that
he certainly didn't have an easy life. He was a fisherman in his
youth, but as the catch grew meager, his father suggested that he
change jobs. So Kiichiero went to Muroran to work at an iron plant.
Despite the hard work, he still found time to read—one of his
passions. Kiichiero is proud of his good memory and that he can
remember things that happened a long time ago in precise detail.
And he can still take care of himself quite well. He just polished
his shoes to a high shine again. After all, they must look good, and
so must he, when he goes to visit an old friend.

# Tonia Nola

SILANUS, NUORO PROVINCE, SARDINIA, ITALY

---

Tonia Nola has always lived in Silanus, a small, beautiful village located at the foot of Mount Arbo in Sardinia. It is a region known for being home to the many of the world's centenarians. Tonia lives with her grandnephew's family—she never married and has no children—and worked all her life as a housemaid. In her 20s, she worked for a retired officer who was part of the *Spedizione dei Mille* (Expedition of the Thousands), who fought under Giuseppe Garibaldi (1807–82) against the French Bourbon army. Her advice for how to live a long life? "Working with serenity and without stress, not being jealous, and eating a lot of minestrone."

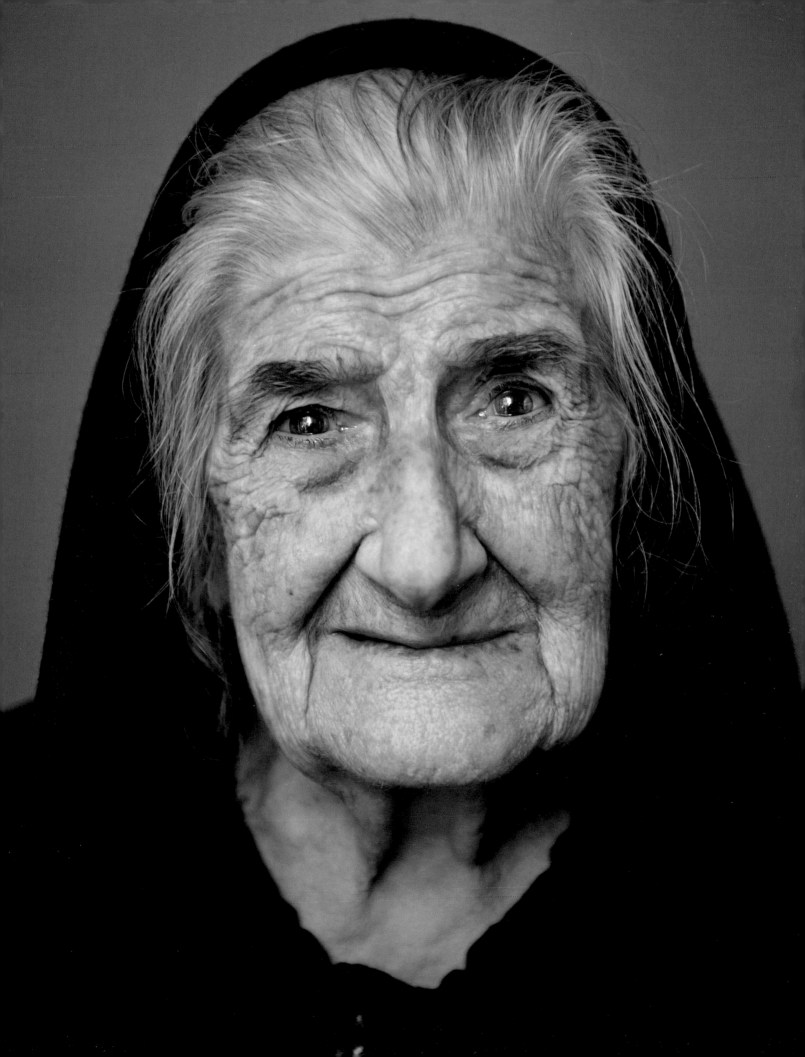

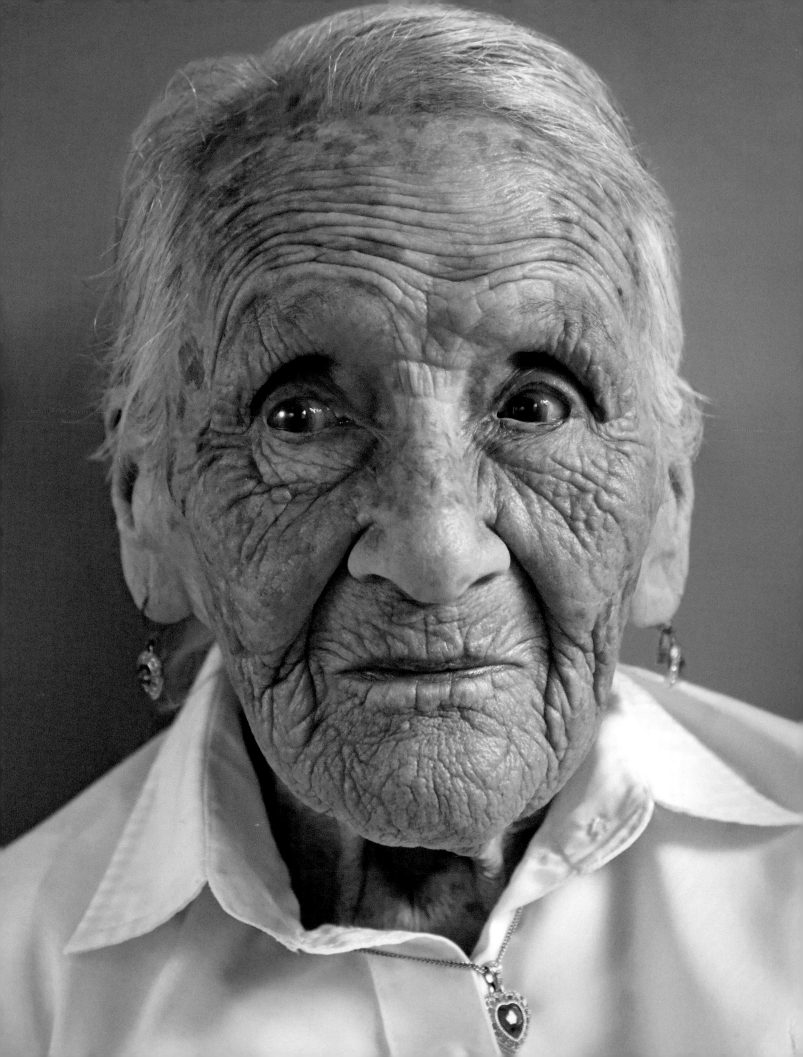

# Ursulina de Jesus Ochoa Ontaneda

LOJA, ECUADOR

---

A former modist—a mix between stylist, fashion designer and tailor—Ursulina is convinced that to achieve a long life it is necessary to stay young in your mind. To do this, she keeps tabs on what's going on in daily life by studying the local newspaper, *La Hora,* each day. "When I was a little girl I used to read a lot. Most of what I know I learned by reading!" she boasts. While 19-year-old Milton, the youngest of her 14 grandchildren, is combing her hair and fixing her earrings for the photo session, she talks about her husband—Romulo Salazar, a telegraph operator, who passed away 26 years ago—their five children (three sons and two daughters), fourteen grandchildren, twelve great-grandchildren, and one great-great-grandson. Ursulina now lives with Milton's mother, Ursula, who's in the living room preparing a traditional café Lojano, together with cake, bread, and local milk cheese. Ursulina has one piece of advice for a long and good life: "Always try to avoid displeasure and anger."

# Kunimasa Ogura

SAPPORO, HOKKAIDO, JAPAN

---

When Kunimasa was only 16, he left his hometown and went to Sapporo where he saved enough money to get his driver's license and eventually become a taxi and truck driver. Then Kunimasa had the opportunity to participate in the construction of the cable car in Niseko, one of the snowiest regions in the world, of which he is very proud. His skill set made him very attractive to the army, and he was deployed several times to war zones. His experiences in war may be why he finds it so important today to be a friendly and kind person.

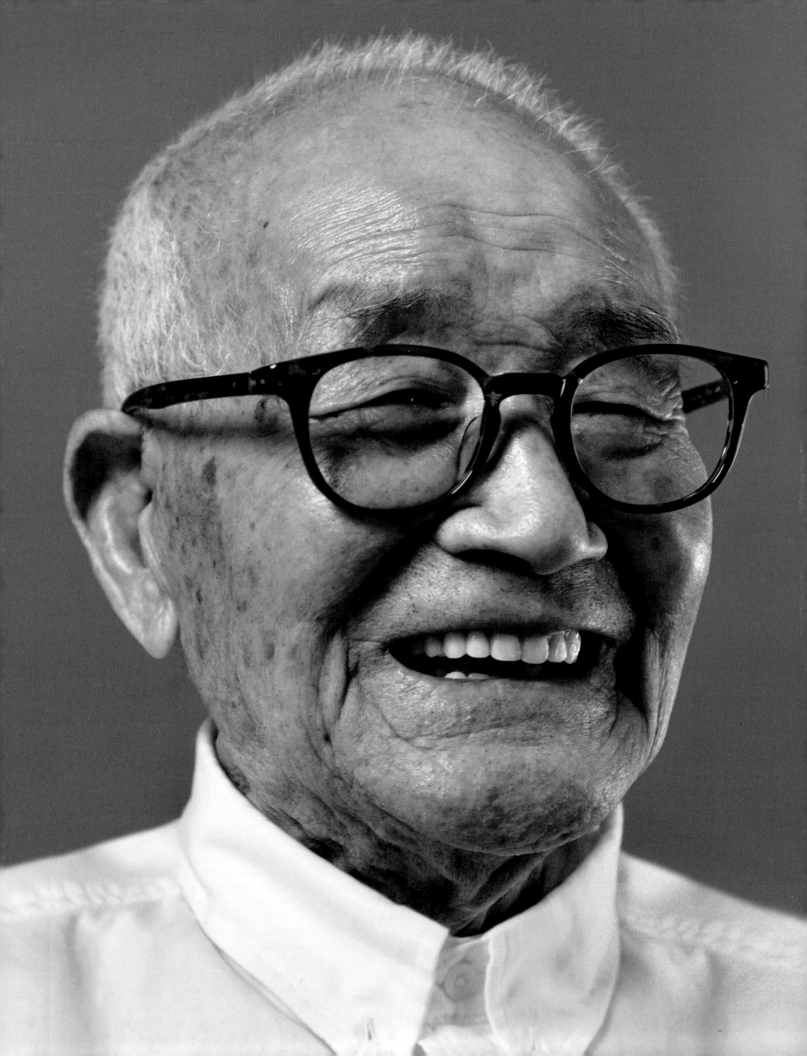

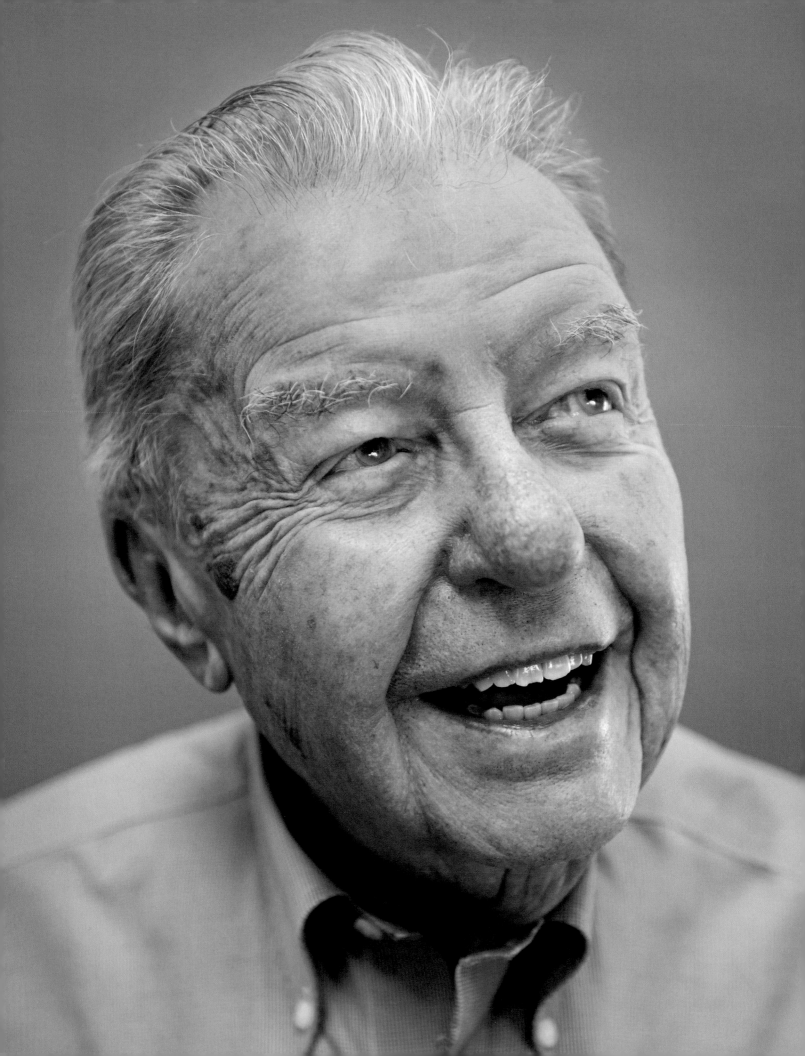

# Edward J. Palkot

GARDEN CITY, NEW YORK

---

Former human resources director Edward Palkot was waiting in his beige sedan limousine to pick me up at the train station in Garden City, New York. "Without my car, I would be lost," he says while driving to his favorite lunch spot, Leo's. We pass his golf club where he goes once a week with three friends, the small concert pavilion at a public park where he will go tonight, and a dance hall where he is also well known for showing up with his 89-year-old partner, Alice. His wife, Anne, who was of Lithuanian heritage, died of ALS in 1998. Since then, he's quite happy to have found somebody to love again.

# Antonino Porcu

BORORE, NUORO PROVINCE, SARDINIA, ITALY

---

Antonino Porcu was an only child, raised by his mother while his father went off to the United States and started a new life. He proposed that his son join him, but Antonino stayed in Italy to be with his mother. He and his wife, Giacomina, brought up nine children, seven of whom are still alive. He worked for 33 years as a forester in the woods of Monte Sant'Antonio, between Borore and Macomer, and has lived alone since Giacomina passed away in 1992. His advice to younger generations: "Work hard and do good. Always!"

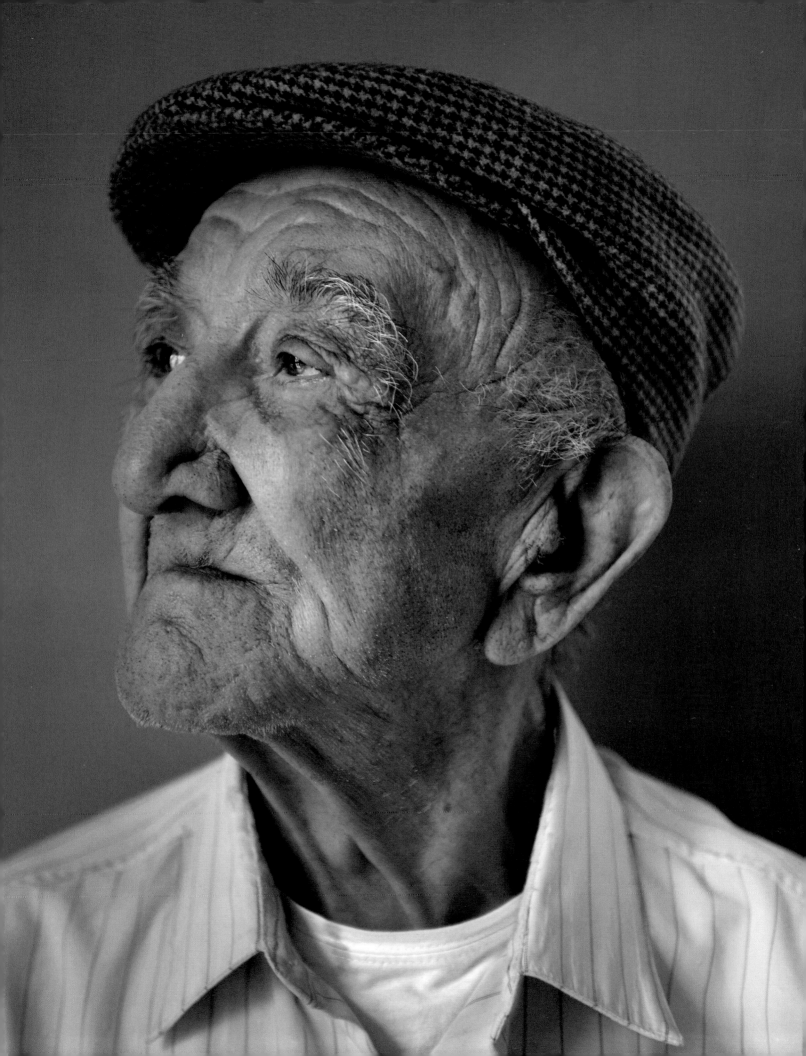

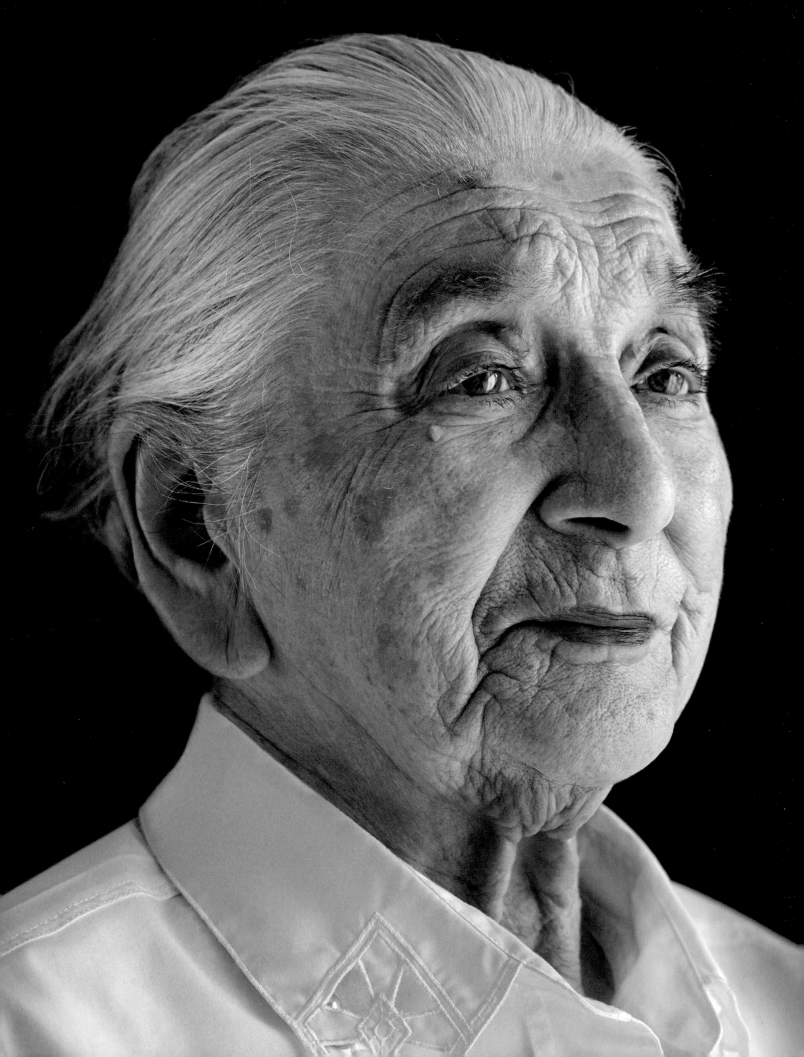

# Berta Maria Frieda Preiss

NIDDA, HESSE, GERMANY

---

Berta is the youngest of five children. As was the norm for the women of her generation, she went "into service" at her aunt's in Nidda, where she helped in the house and the inn. There she met her husband, Karl, with whom she ran a small local grocery store until the end of the 1970s. As she grew old, she still got around on her bike and cooked for her family, children, and grandchildren until she was nearly 100 years old. Today she still goes to church regularly and says that, if you want to become as old as she is it is best not to overdo anything.

# Ursula Rüdel

DORNDORF-STEUDNITZ, THURINGIA, GERMANY

---

The former pediatric nurse gets up every morning at 8 a.m. and cleans her apartment on the first floor of her son's spacious home. From her terrace, Ursula has a great view over the Saale River Valley. She loves to sit here after finishing her housework and read the newspaper or write letters to her family and friends, which helps "to keep me mentally fit." At her age, it doesn't bother her too much that her hearing and mobility are limited, or that she's forgetting things faster. What she misses most is not being able to go shopping for herself. But her six great-grandchildren keep her busy and entertained.

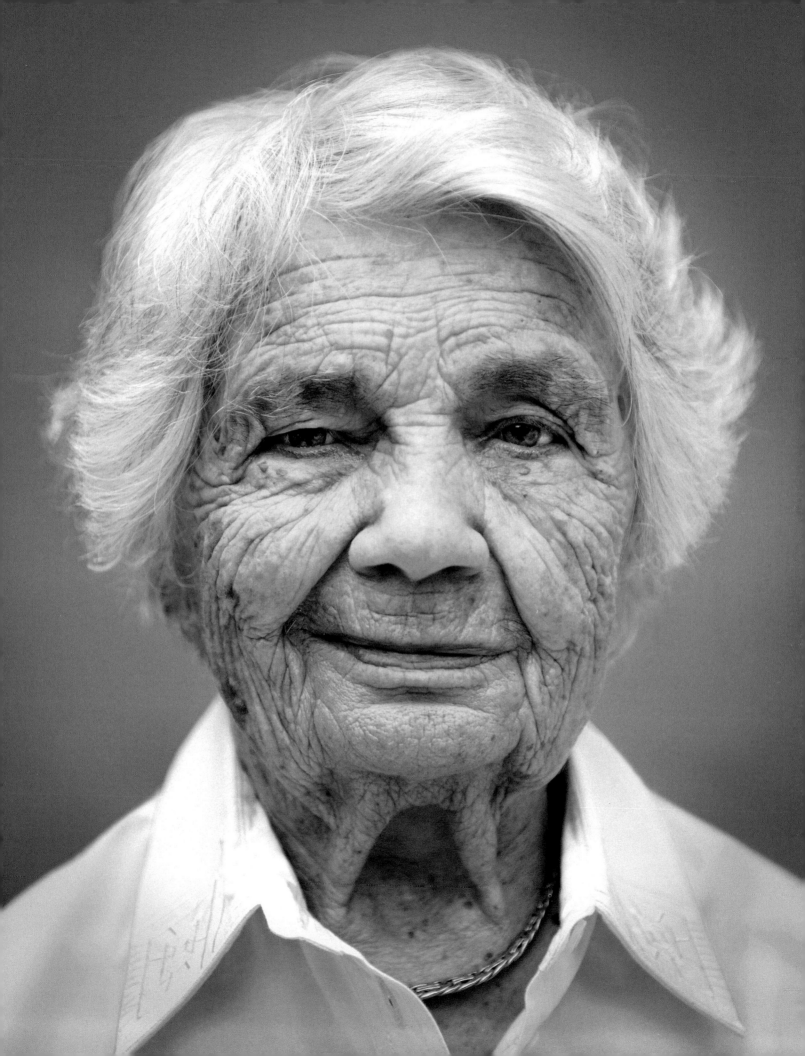

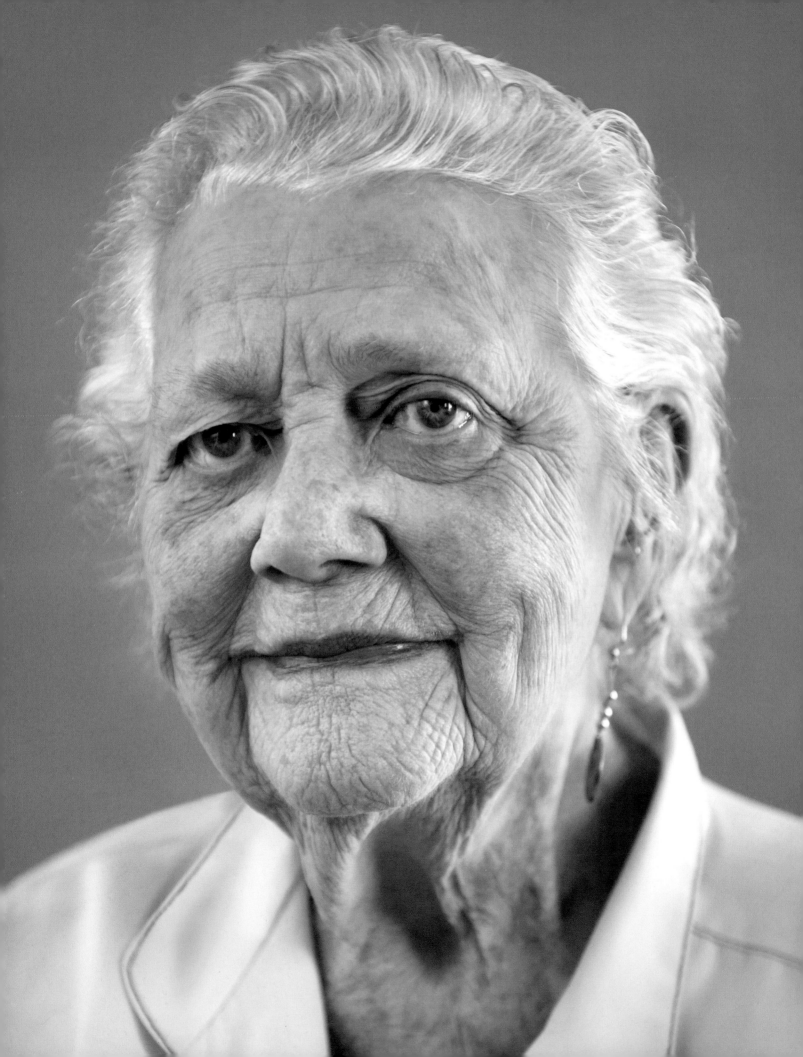

# Marie M. Runyon

HARLEM, NEW YORK, NEW YORK, USA

---

Marie is a real New York City attraction, famous for her determination and her dedication to making the city a better place to live. Her clash with Columbia University, which tried to throw her out of her Harlem apartment, made her a legend. The battle lasted 40 years and ended in 2002—in an armistice and with the building being named Marie Runyon Court. She was called an "unreconstructed leftie" in an article run by the *New York Times,* and is now more dedicated than ever to her activities—including the Granny Peace Brigade, an organization of elderly women who fight for peace. On top of all that, she takes on minor roles in films now and then; in 2008 she played one of the guests in the movie *Rachel Getting Married.* Although she has lived in New York for more than 70 years, you can still make out the soft accent of the American South when she advises us not to always do what others tell you to do.

# Kimiyo Sato

TOKYO, JAPAN

---

Kimiyo has a weakness for cars made in Germany. She got her driver's license when she was 50 years old and drove her red Mercedes until she was 94. She raised six daughters, but tragically her twins died in a gas-explosion accident at the age of 15. She has eight grandchildren and nine great-grandchildren. Kimiyo's daily schedule is packed: Breakfast at 8 a.m., shopping, senior center activities, painting classes, and, of course, Sunday mass. She is faithful and begins her days by praying, and she prays three times before any meal. "Praying, and being altruistic and helpful to others, is most important," she says.

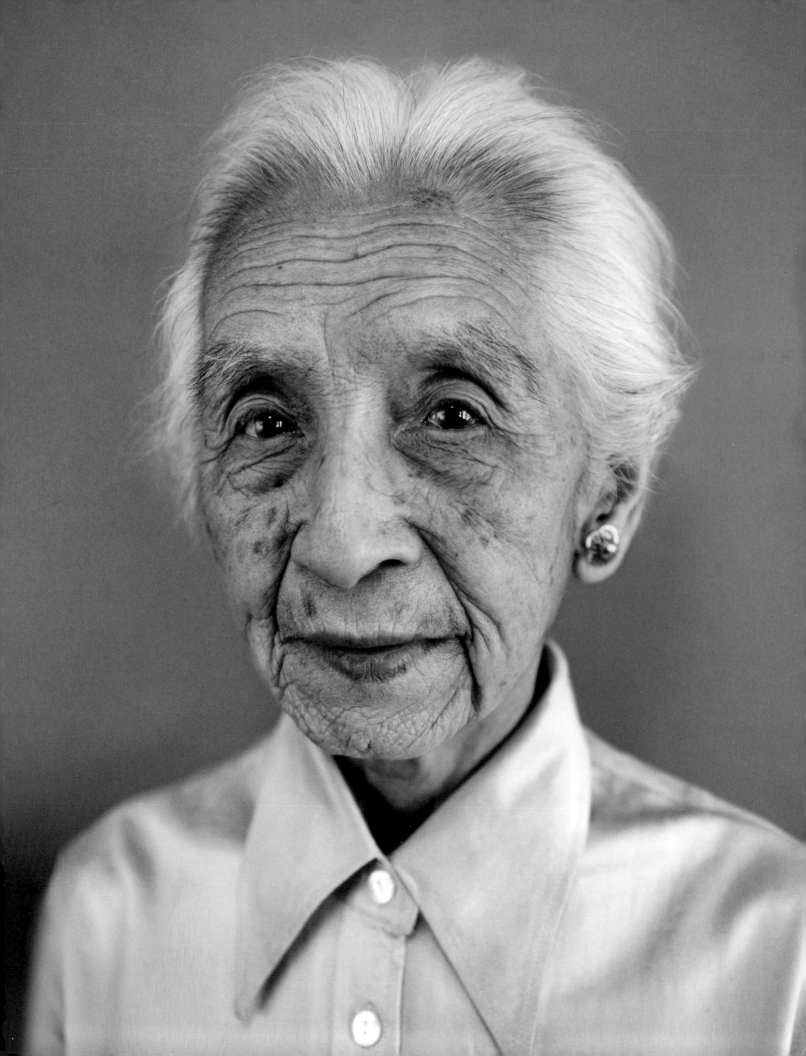

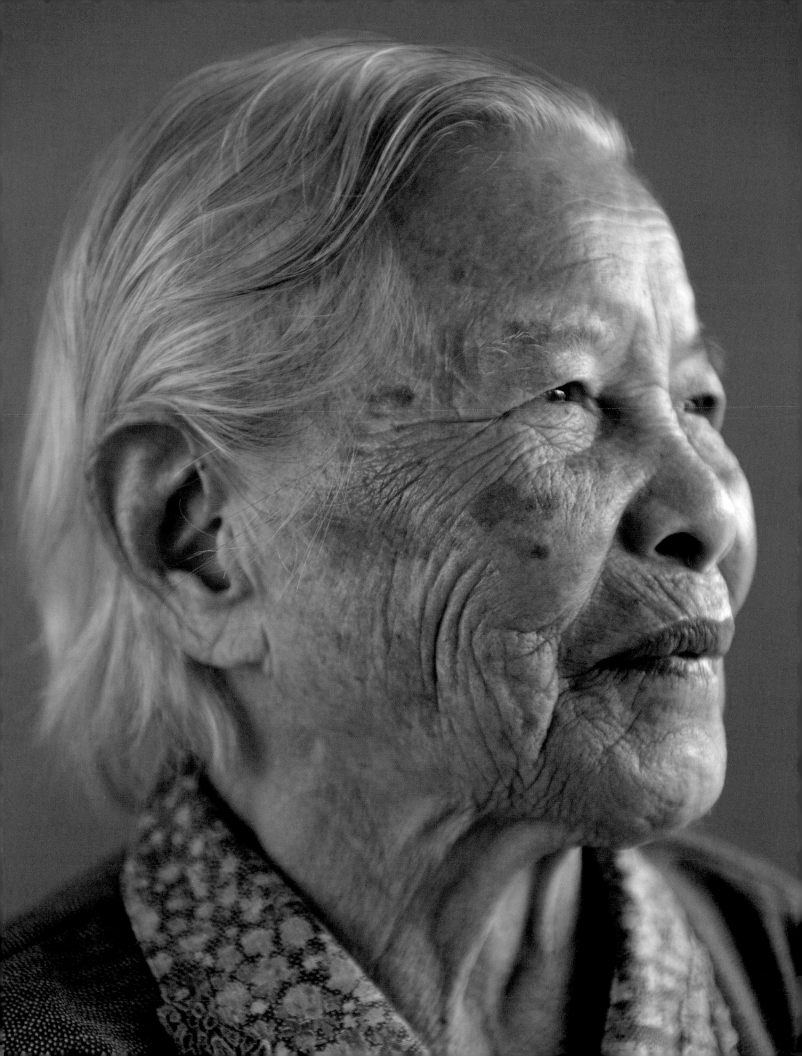

# Miyagui Sayo

ŌGIMI, KUNIGAMI DISTRICT, OKINAWA, JAPAN

---

Miyagui says she feels much freer now than in her youth. It may be the remoteness and tranquility of Ōgimi, or maybe the healthy diet—most people here grow everything they eat—that allows locals to grow so old. But even here, staying healthy and active certainly requires a high level of discipline: "I'm doing gymnastics and listening to the news every morning," says Miyagui, who has been a widow for 15 years. "It's important not always to stay at home, but to do something with others," she says. When she's not working in her garden, Miyagui strolls through the village and chats with the neighbors. Or she writes in her diaries. "They pile up at home. I wanted to throw them away." But her six children and twenty-eight grandchildren have convinced her to keep them.

# Leif Solberg

LILLEHAMMER, NORWAY

---

Leif was one of the most famous organists in his country. His career began with an early debut when his father, an organist for several churches, became ill. Twelve-year-old Leif filled in, although he could barely reach the pedals. Later his music studies took him to London, Salzburg, Copenhagen, and Haarlem. He was the church organist in Lillehammer from 1938 until 1982, and taught at the music college there. He has been married for 75 years. His wife, Reidun, was 15 when they met—"the most beautiful alto voice" of the choir, which the then 24-year-old Leif founded and directed in Toten.

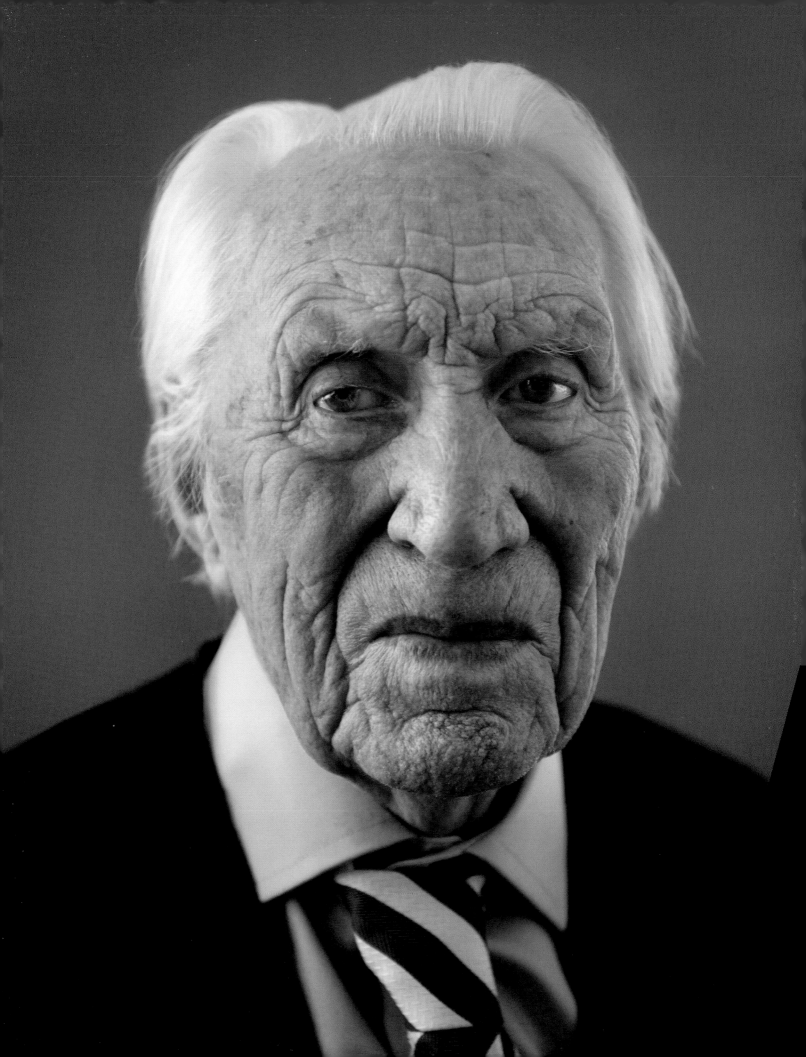

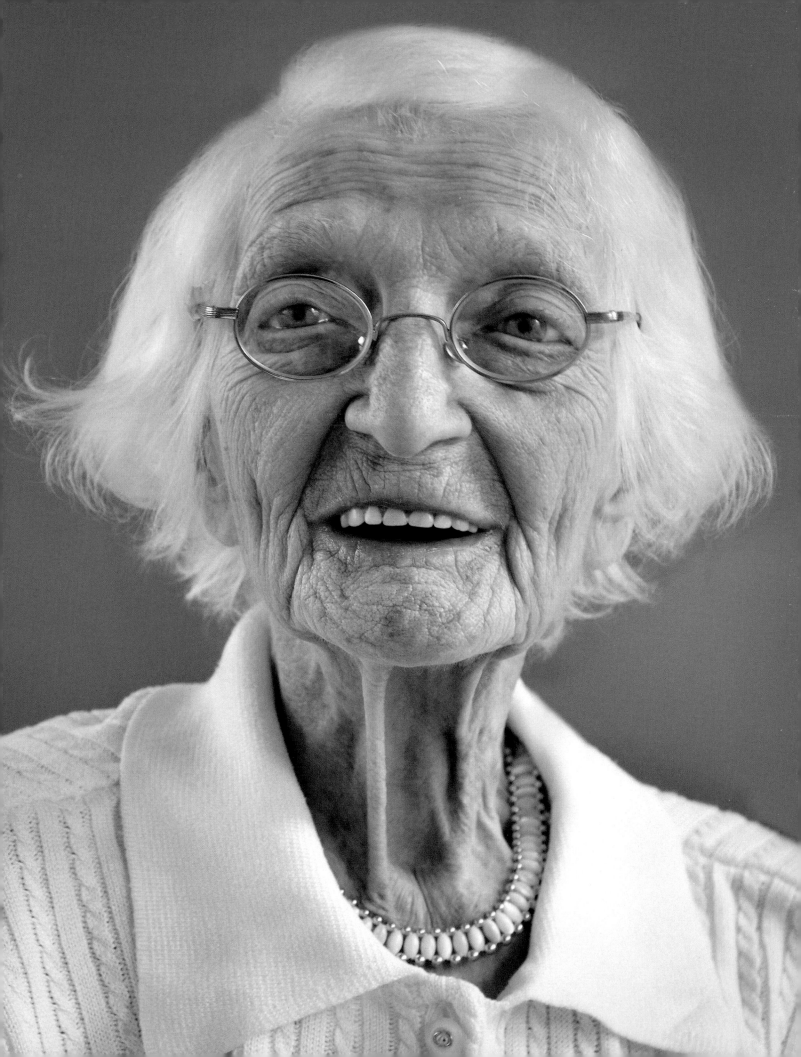

# Johanna Spiekermann

LEIPZIG, SAXONY, GERMANY

---

"My life was never a bed of roses," Johanna says. She was only 24 when her husband died in World War II. From then on she had to get by on her own with her three daughters. She worked in a sawmill, served in an inn, sewed carnival costumes, and opened a costume rental service. "A certain defiance" to stand up to life and its tough challenges, she says, is perhaps not such a bad recipe for a long life. And some additional wisdom: "You should always keep moving."

# Consuelo Torres Tello

SAN JUAN DE MIRAFLORES, LIMA PROVINCE, PERU

---

They call her *La Madre de los Cerros,* the "mother of the hills."
Consuelo has devoted her entire life to the weak, and to mothers
and children. She knows all too well what it's like to be poor—as
a child, she had to work and earn money to help support her family.
As a young woman she began to fight for change. She founded the
first soup kitchen and the first mothers' club in her district, worked
to prevent unfair evictions, and gave her love wherever it was
needed. For this she was nominated several times for the Prince
of Asturias Award, and was given awards by UNICEF and the
Congress of Peru. Her recommendations to other women are that
they be noble, give their love to others, and stand up for the poor-
est among us.

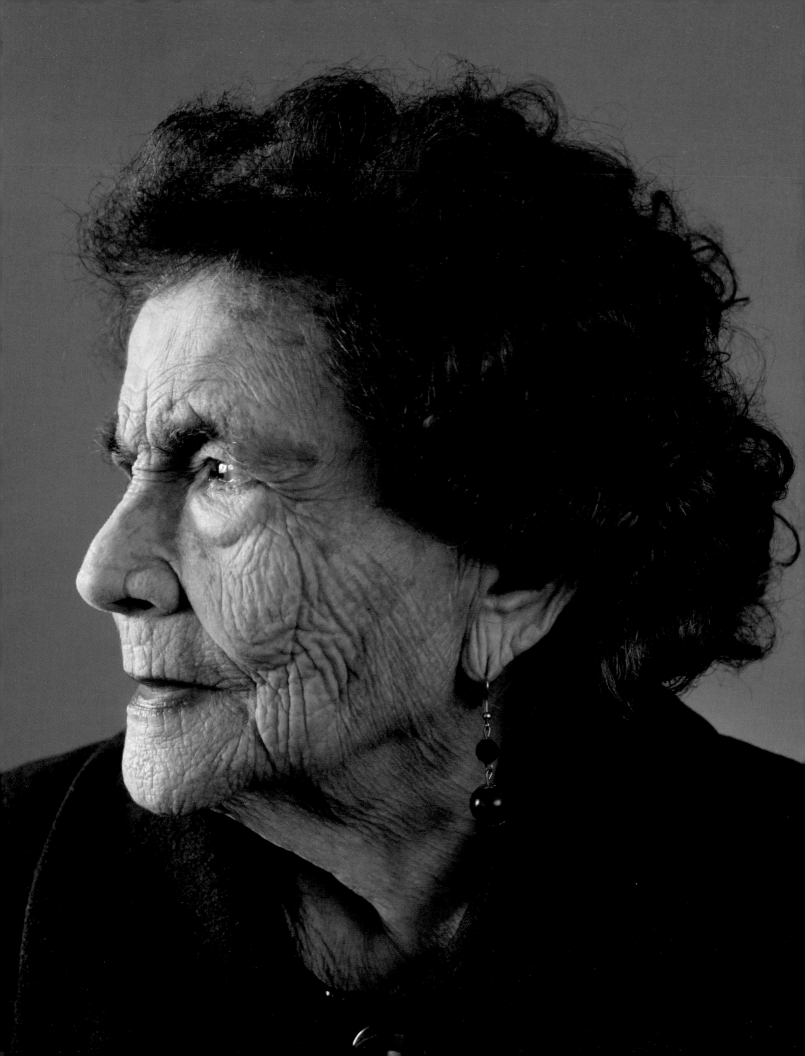

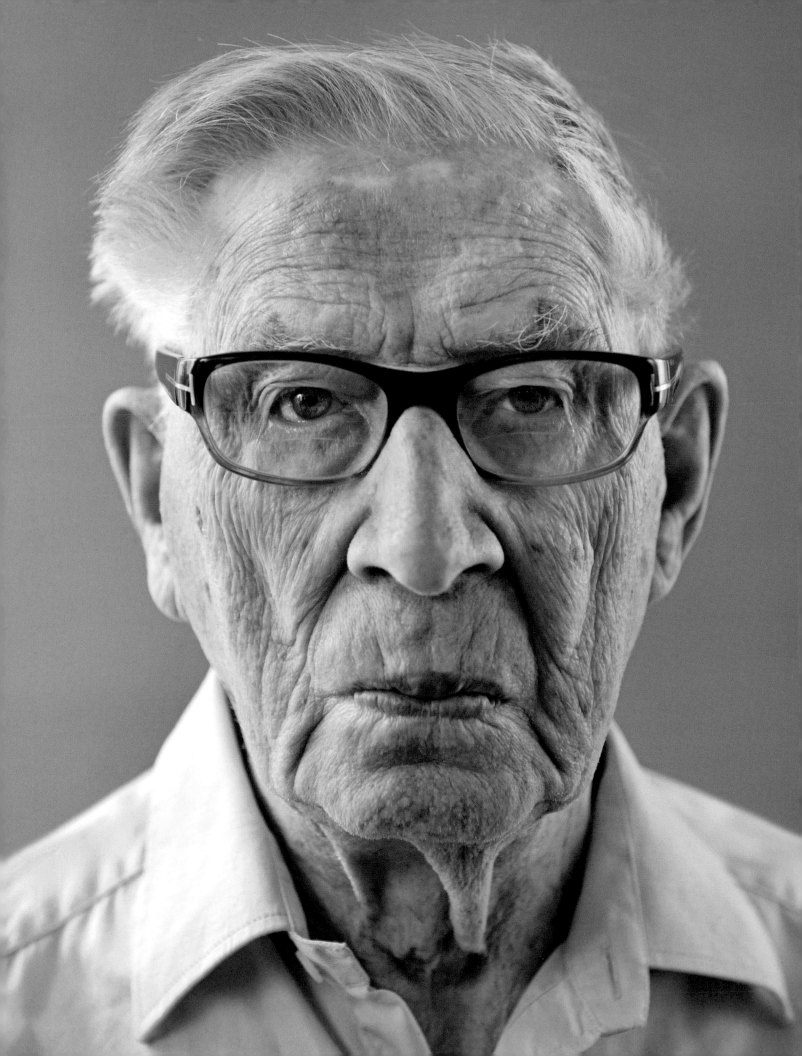

# Per Tønder

NØTTERØY, VESTFOLD, NORWAY

---

Per Tønder was a highly decorated man and very popular because of his generosity, sense of humor, and active social engagement. Per was ordained as a priest in 1940 and served for 20 years as a mayor of the city of Salangen. After becoming a politician for the Labour Party, he served as a deputy representative to the Parliament of Norway from Troms for three terms. He was decorated with the King's Medal of Merit in gold, a Norwegian award given for extraordinary achievements of importance to the nation and society, in 1981.

# Luz Pacifica Torres

VILCABAMBA, LOJA PROVINCE, ECUADOR

---

Luz is Timoteo's (page 21) sister-in-law. Her husband, Victor, who died in 2010, was his brother. The family used to run a farming operation together. It was hard work—which, according to Luz, enhanced her longevity. But maybe the secret also lies in the mysterious ishpingo, brewed with Punta—the schnapps that Timoteo distills himself. Ishpingo is Luz's cure-all for the few maladies that sometimes befall her. Luz has six daughters and two sons. She is not quite sure how many grandchildren and great-grandchildren she has. There must be between 30 and 40—a number that even younger people would lose track of. At least her progeny has been properly registered with the authorities—unlike Luz, who officially does not even exist. The path up the mountain to her wooden hut is so drastically steep that not a single civil servant has ever taken it upon himself to issue her an official ID card.

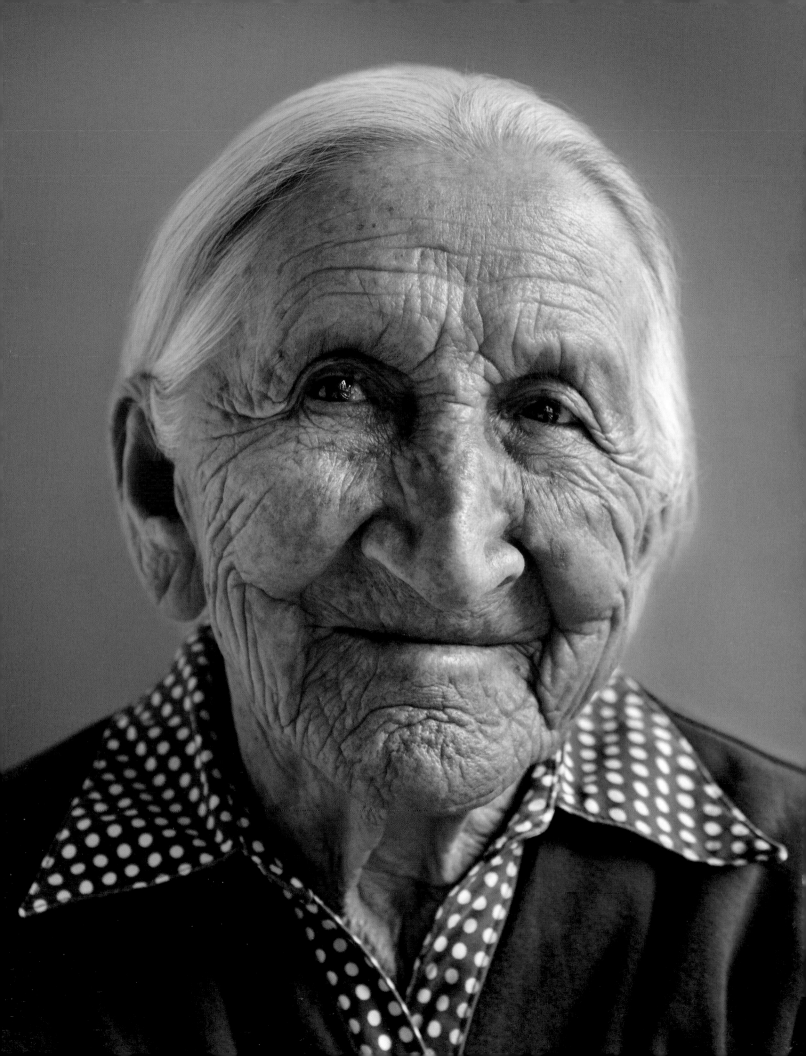

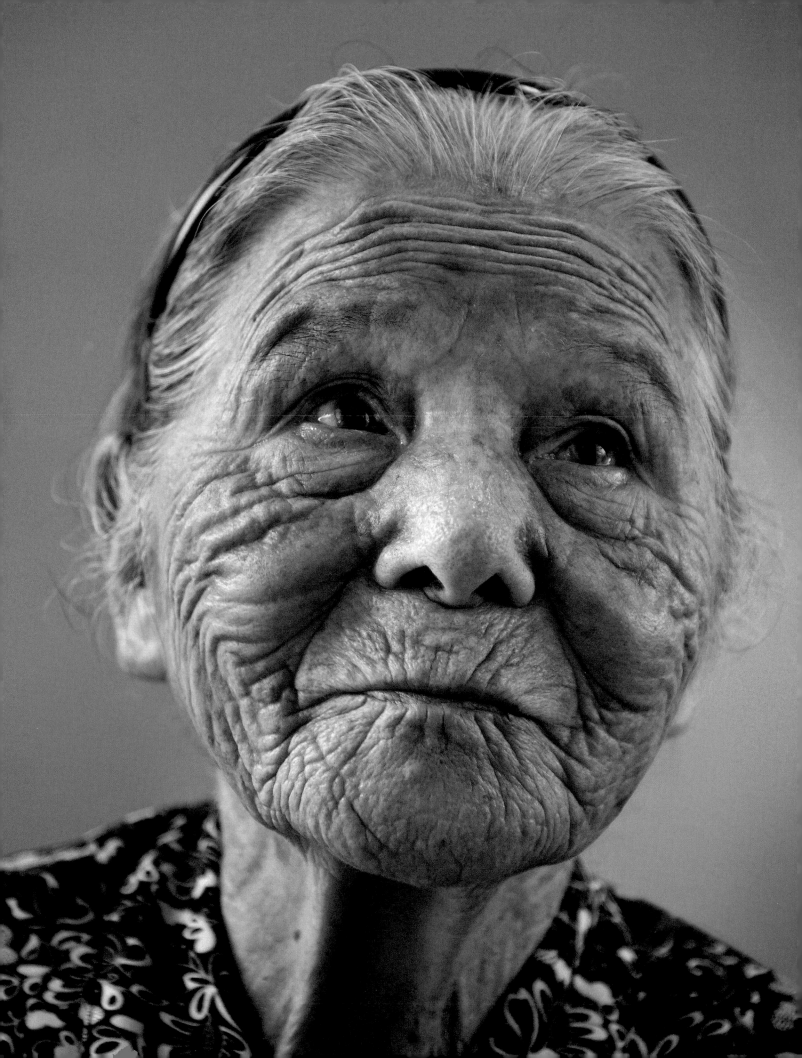

# Tonaki Tsuru

NANJŌ, OKINAWA, JAPAN

---

Tonaki Tsuru lives on Okinawa, one of a group of Japanese islands in the East China Sea and world-record holder for having the most centenarians. When she was younger, Tonaki worked at a fabric factory to make a living and raise four children together with her beloved husband, who passed away more than 50 years ago. These days her favorite pastimes are growing sweet potatoes and performing traditional Okinawan folk music on a *shamisen,* a guitar-like Japanese musical instrument with three strings and a long neck. Every weekday, Tonaki enjoys going with other women from her city to a senior center, a typical Japanese facility for single seniors, where she works out, chats with others, and receives health care.

# Fritz Tasso Tuche

JENA, THURINGIA, GERMANY

---

Fritz was a carpenter, construction engineer, and lecturer at the Fachschule für Bautechnik Neustrelitz, a construction engineering college. He still has strong opinions about the development of Jena, where he moved following the death of his wife. He also has a couple of tips, which he shared with the Jena mayor's representative, who visited him on the occasion of Fritz's 101st birthday. One is singing, preferably in a choir. Fritz is still very active—he goes shopping, cooks by himself, and still goes on fishing trips with his grandchildren. And he continues to travel, as he did last year with his family to Norway.

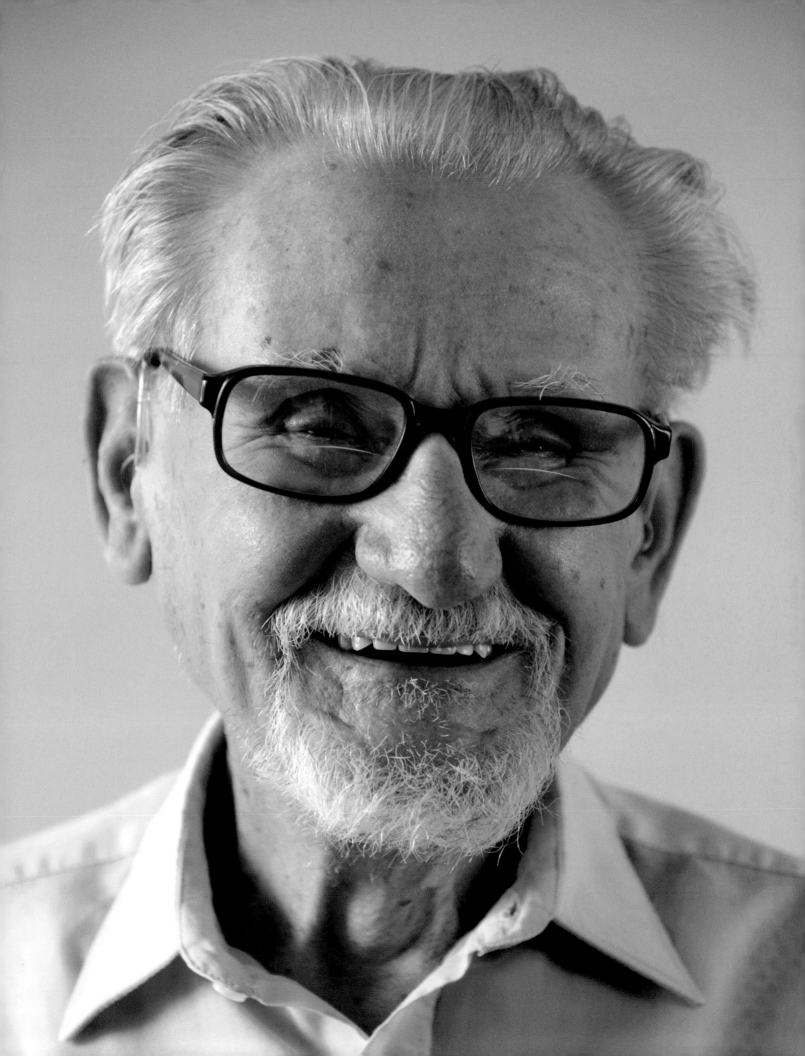

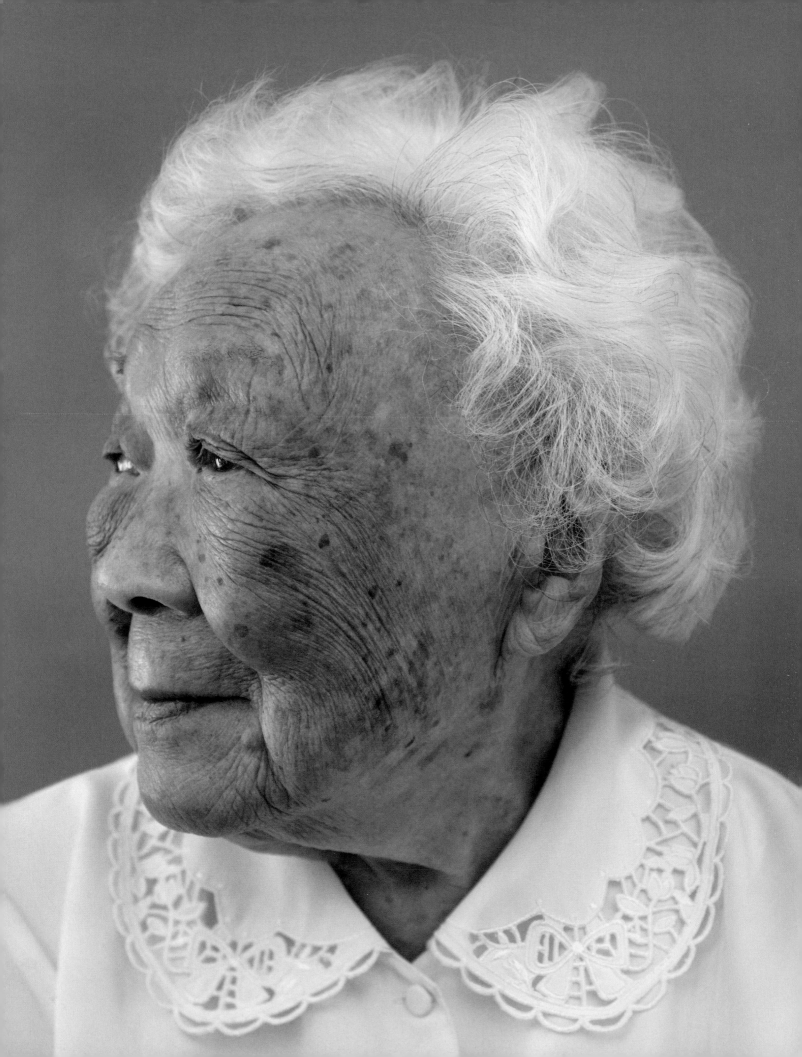

# Lillian Wong

ATHERTON BAPTIST HOMES,
ALHAMBRA, CALIFORNIA, USA

---

"I can't keep a secret!" Lillian declares. The small, lively woman has lived through eventful times. During the Second Sino-Japanese War she lived in China, where her husband, David, was occupied with the planning of railway lines and military airports. Later she moved with him and their two children to Hong Kong. Though Lillian originally studied sociology, she found work in Hong Kong as an English teacher. Lillian believes that she owes her advanced age to her faith in God, and also to the advice of her father, a specialist in Chinese herbal medicine. She claims to have learned a lot about healthy eating from him and to avoid "processed food" as much as possible. "I am very fussy about what I eat. I take vitamins and avoid junk food." Maybe her last name has something to do with it: Wong means "yellow," which in China is the color of life.

# Jiro Yasutsugu

NAHA, OKINAWA, JAPAN

Jiro Yasutsugu claims that he has gone around the world several times over onboard ships, where he worked as a machine operator. Unfortunately he hardly saw anything of the world outside the machine room when the boats stopped—rarely was he allowed to leave the ship and go on shore leave. This is why he now loves to watch television reports about faraway lands. But he has no real regrets, he says. The father of one son and grandfather of three grandchildren, Jiro is very much at peace with himself and his life. He says if he ever met a good and kind-hearted fairy, he wouldn't even know what he could possibly wish for. "I really have everything I need."

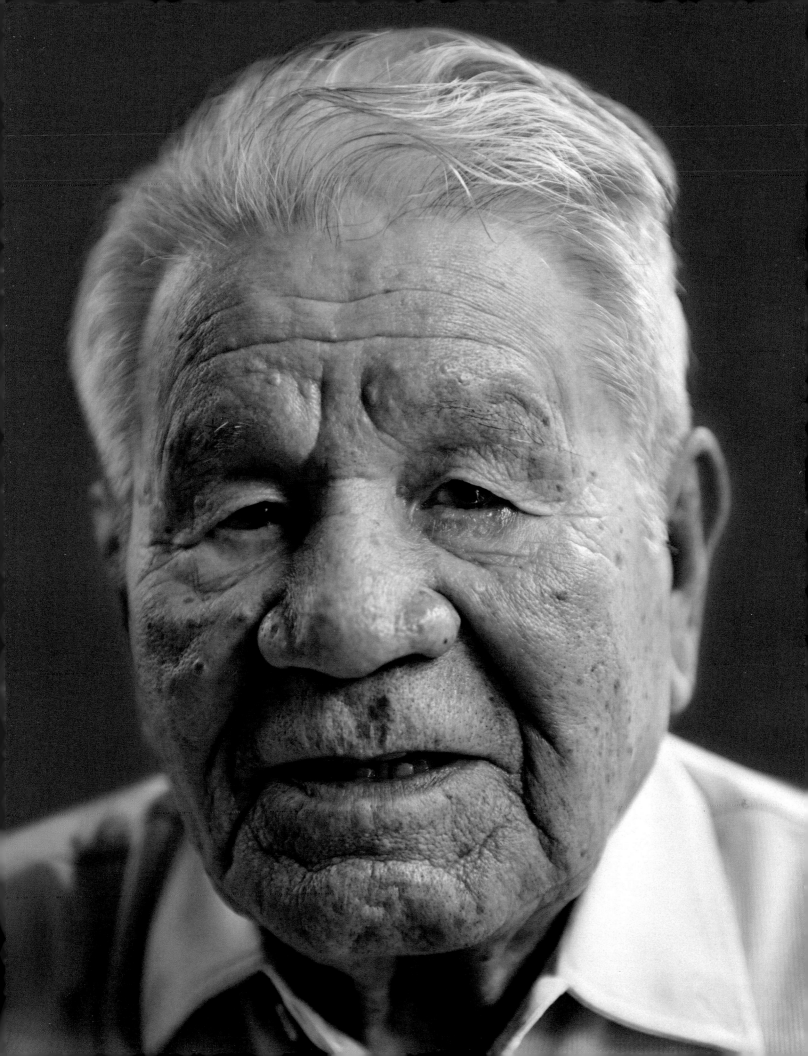

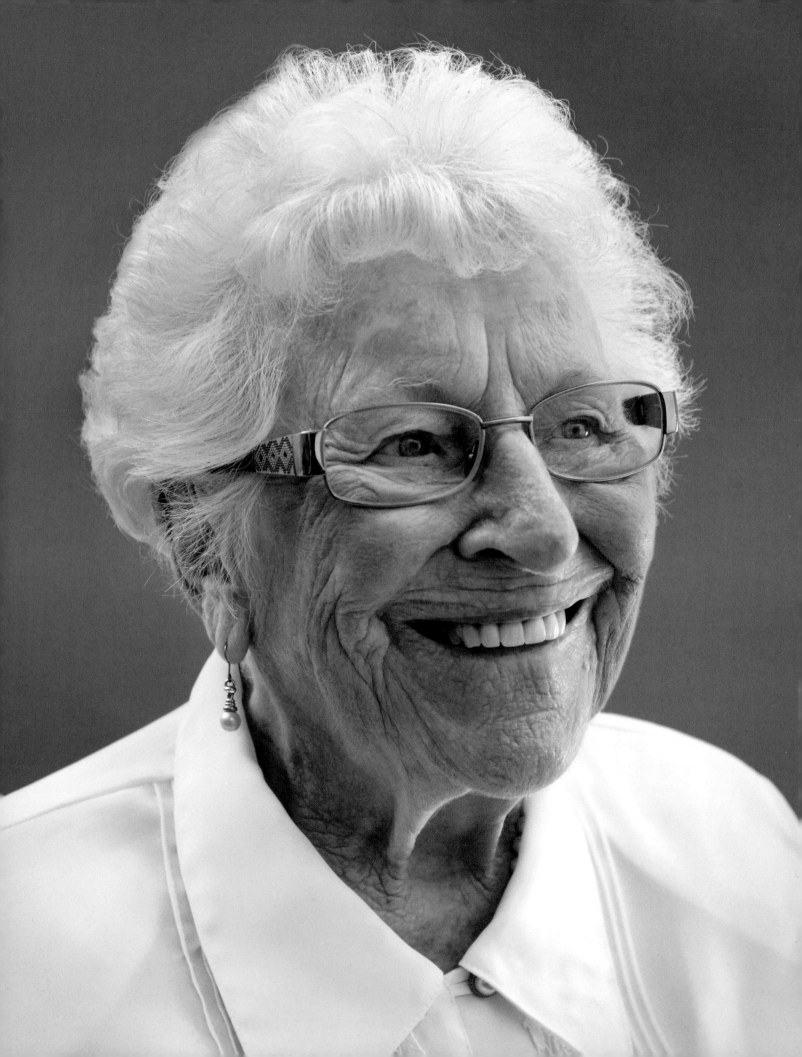

# Evelyn Zehring

ATHERTON BAPTIST HOMES,
ALHAMBRA, CALIFORNIA, USA

---

Evelyn strongly believes that God has a good reason for her "still being around! I'm praying that I will be ready for whatever He has planned for me." For the moment, those plans include living in a Baptist residence that was founded in 1914, the same year she was born. Evelyn gives weekly Bible classes there and plays music on the piano to accompany the church service. She does this in the spirit of her husband, Guy Raymond Zehring, a Baptist priest, who made her a widow back in 1968. During his life, her husband's work as a priest took them wherever he was called to serve—Washington, Oregon, Ohio. She has three children, eight grandchildren, fourteen great-grandchildren, and four great-great-grandchildren. When she's not giving Bible classes or playing the piano, she meets her friends to play dominos—one of her favorite pastimes.

# Acknowledgments

A heartfelt thank you to all the centenarians who so kindly agreed to pose for their photographs. I'd also like to thank their spouses, relatives, and friends, as well as the management and staff of many facilities, for their support. It was a pleasure working with all of you.

I'd especially like to express my gratitude to Masatada Araki, whom I met a few years ago in Berlin. Masatada became an altruistic guide and most faithful companion during my journeys to Japan.

Huge appreciation also goes to Federico Sedda and Raffaella, for their great support in researching in Sardinia; Sofia Egilsdottir for attending us in Iceland; Noby Noda, Keizo Matsuki, Masaaki Hiromura, Junichi Saito, as well as his team from Light Publicity, for producing a beautiful series of centenarians commissioned by Tokushu Tokai Paper and COOP Sapporo; Sandra Lourenco for accompanying me in Norway; Diana Toledo, Stefanie Faller, and Milton Ojeda for introducing me to so many wonderful centenarians in Vilcabamba and Loja, Ecuador; and to Helga Elsner and Carina Moreno for introducing me to Giuliana Ghersi, who guided me safely in Lima. And I'd like to thank Michael Ash for recommending Maria Cabrera, who did an excellent research job in Los Angeles.

A big thank you to my fabulous writers: Constanze Kleis for the professional text editing; and Géraldine Elschner for the research in France, her contributions, as well as the interviews and interpreting in Paris. Many thanks to Greg Palkot for introducing me to his lovely father, Edward, who was so kind as to give me an unforgettable Garden City sightseeing tour in his sedan and for submitting the foreword to this book. Thank you Deborah Lo for all your help with translations.

Thanks to my wonderful wife, Michaela, for organizing and accompanying me on many trips, for all the support and coordination, and for the bookings, filming, and assisting. A big thank you to my assistants, Charlen Christoph, Paul Gerlach, and Moritz Reich, for the ongoing support, and to makeup artists Mitsuki Konno, Susanne Roitmeier, Rozemarijn Schoh, and Anna Tsoulcha.

This book would never have been possible without the encouragement and support of my Chronicle Books editors, Bridget Watson Payne and Rachel Hiles. Thanks to you for believing in the success of this project, and to all the talented graphic designers involved in its beautiful layout.

I'd like to thank Janina and Roger Nitsch as well as Guido Studer for their continuous support on this project since its inception. Thanks to Ingeborg Müller-Just, her father, Walter Just (1921–2012), and her daughters, Katharina and Stephanie, for showing my centenarians in their wonderful museum in Wels, Austria; and to Ralf Kleist, for casting many centenarians in Thuringia and presenting them in a fabulous show to more than 15,000 visitors at the City Church St. Michael in Jena, Germany.

I am also indebted to the municipal administrations of the cities of Nanjō and Ōgimi, Okinawa; the tourist office of Vilcabamba; and the general management of Hrafnista in Reykjavik, Vandalia Houses in Brooklyn, and Atherton in Los Angeles.

I'm very happy to have met you all, and to have you in my life and memories.

SPECIAL THANKS TO:

Edith Akins-John, Manato Akira, Osamu Arakaki, Yasuko and
Masatada Araki, Antonia A. Arena, Maho Asai, Olivia Baier,
Gesa Li Barthold, Carola Boers, Vera Bohren, Hannah Booth,
Monika Braun, Mara Cardu, Keiko Char, Catherine Chevallier,
Tore Cossu, Christa Descher, Jacob Falck, Beate Frauenschuh,
Ursula Friedsam, Oscar Ghersi Winder, Tore Ghisu, Karin Rissa
and Karl Otto Götz, Thomas Gunzelmann, Sabine Hampel,
Jessica von Handorf, Karin Herzog, Shigeaki Hinohara,
Yoshikazu Ichimura, Anne Jahnsen, Lois Judge, Eva-Marie
Kessler, Annemarie von Kienlin, Eugene Kim, Georgia Frances
King, Ingrid Klambauer and Walter Aspernig, Nina Klein, Akira
Kobayashi, Abe Kota, Etsuko Kushido, Sabine Landau, Angela
Lee, Rosa Leone, Giovanni Agostino Longu, Sandra Mann, Mami
Maruki, Elias Mele, Luigia Mele, Helen Meyrahn-Schaeffer,
Kiyotoshi Misawa, Miyuki Nakayama, Jochen Nitsch, Ursula
Salazar Ochoa, Yoshinori Oe, Yoshiichi Ohnaka, Kinichi Okagawa,
Misao Okawa, Hideaki Omi, Angela Maria Ortu, José Pillcorema,
Alice and Giovanni Porcu, Christoph Rott, Cécile Roumiguière,
Louise Russell, Werner Sägesser, Junichi Saito, Sekine Sayaka,
Claudia Schenk, Brigitte Schmidt, Elfriede and Wolfgang Schmidt,
Elisabeth Schöne, Lisabeth Schöne, Kerstin Schweighöfer, Seiji
Shinohara, Sigurveig Sigurðardóttir, Bärbel Strohm, Clemens
Tesch-Römer, Sumi Teufel, Bard Tønder, Tonaki Tsuru, Jean-Luc
Valentin, Josette Valentin, Marion Walter, Ken Watanabe, Jennifer
Wright, Masashi Yamamoto, Mitsue Yamashita.